PAUL KLEE
Masterpieces of the Djerassi Collection

PAUL KLEE

Masterpieces of the Djerassi Collection

Edited by
Carl Aigner and Carl Djerassi

With texts by
Carl Aigner
Janet Bishop
Carl Djerassi
Kelly Purcell and
John S. Weber

Prestel
Munich · Berlin · London · New York

This book accompanies the exhibition *Paul Klee—Masterpieces of the Djerassi Collection* at the Kunsthalle Krems from 16 June to 29 September 2002. Exhibition and catalogue were produced by the Kunsthalle Krems in association with the San Francisco Museum of Modern Art.

www.kunsthalle.at
www.sfmoma.org
www.djerassi.com

Editors: Carl Aigner, Carl Djerassi
Curator: Carl Aigner
Authors: Carl Aigner, Janet Bishop, Carl Djerassi
Picture commentaries by Janet Bishop, Kelly Purcell, John S. Weber
Project co-ordinator: Julia Kordina
Editorial board: Julia Kordina, Jutta M. Pichler, Isabella Swetina (Krems)

Carl Aigner's texts, the interview, and chronology translated from the German by Christopher Jenkin-Jones, Munich

Die Deutsche Bibliothek – CIP-Einheitsaufnahme data and the Library of Congress Cataloguing-in-Publication data is available

Front cover: Paul Klee, *Kleine Winterlandschaft mit dem Skiläufer*, 1924 (cat. no. 42)
Back cover: *Blau mantel*, 1940 (cat. no. 83)
Frontispiece: Paul Klee, Bern, 1911

Prestel Verlag
Mandlstrasse 26
D-80802 Munich
Tel. +49 (89) 38 17 09-0
Fax +49 (89) 38 17 09-35
info@prestel.de
www.prestel.de

Edited by Christopher Jenkin-Jones, Munich
Design by Saskia Helena Kruse, Munich

Lithography: Trevicolor srl, Italy
Printed by Sellier Druck, Freising
Bound by Conzella, Pfarrkirchen
Printed and bound in Germany

ISBN 3-7913-2811-5
(German edition)
ISBN 3-7913-2779-8
(English edition)

Contents

Acknowledgments

In his preface to the catalogue of the exhibition in Salzburg, Graz, and Vienna (1986), Otto Breicha speaks of a «hitherto astonishing absence» of Paul Klee's work in Austria. It was the second slightly more comprehensive exhibition to have taken place here— the first being Werner Hofmann's at the new Museum of the Twentieth Century in Vienna in the 1960s. Astonishing indeed. For not only is Klee one of the twentieth-century's most important artists, whose exceedingly rich *œuvre* we still admire today, but his many-faceted artistic personality is also unique: as graphic artist, draftsman, and painter, he mingled techniques in fascinating ways. Moreover, he was one of the past century's most important theoreticians and teachers of art, and he also wrote poems—Dadaistic, or in a musical tradition—over a period of three decades. The conjunction of visual art and literature has been a hallmark of Austrian art from the start of the twentieth century to the present (one thinks of Alfred Kubin or Günter Brus), and that alone ought to occasion intensified interest in Klee in this country.

We take great pleasure in displaying today over eighty works from one of the world's most important Klee collections, the Carl Djerassi Collection, comprising one hundred and forty works to date. Carl Djerassi, famous as father of «the pill,» who began building up his collection over thirty years ago, was born in Vienna in 1923. He was forced to emigrate to Bulgaria after the German annexation of Austria in 1938, then to the United States. It is a biographical detail he shares with Paul Klee who, after the National Socialists had assumed power in Germany, was also forced to flee, as a «degenerate» artist in his case, to Switzerland.

This exhibition is the first comprehensive showing of the collection outside California and the United States. It has been made possible by the remarkable generosity of Carl Djerassi and the professional co-operation of the San Francisco Museum of Modern Art, which has housed the donated collection since the 1980s. Focusing on prints, drawings, gouaches, and watercolors, the collection emphasizes the programmatic and technical complexity of Klee's *œuvre*. It gives an impressive overview of more than forty years' continuous artistic activity such as few public or private Klee collections can.

According to Joan Miró, saying thank you is «the heart's remembrance.» I wish to express my deep gratitude, first and foremost, to Carl Djerassi, without whose unfailing commitment this exhibition could never have taken place. The Kunsthalle Krems is proud to be showing his collection in Europe for the first time. I would like further to express my appreciation to the staff of the San Francisco Museum of Modern Art, in particular David Ross, its former Director; Ruth Berson, Acting Co-Director, for her exemplary support; Marcelene Trujillo, Assistant Exhibitions Director; Janet Bishop,

Curator of Painting and Sculpture; Heather Jain, former Curatorial Associate; Kara Kirk, Director of Publications and Graphic Design; Jill Sterrett, Head of Conservation; Amanda Hunter Johnson, Haas Conservation Fellow in Contemporary Art; Antoinette Dwan, Paper Conservator; and the authors of the texts.

Thanks are also due to the Paul Klee Stiftung, Bern, to its Director, Michael Baumgartner, as also to Alexander Klee and Stefan Frey, administrators of the Klee estate, and to the publishers, Prestel-Verlag, who have taken great pains in producing another Klee publication: Jürgen Tesch, Director; Thomas Zuhr, Marketing Director; Georgia Illetschko, Christopher Jenkin-Jones, Dagmar Lutz, translators and editors; and Saskia Helena Kruse, designer.

An exhibition of this kind can only be effected by the prolonged and patient effort of all involved, and I wish, finally, to express my appreciation to the staff of the Kunsthalle Krems, in particular to Christian Bauer and Hans Kollmann, Managing Directors; Julia Kordina, Head of Exhibition Management; Jutta M. Pichler; and Isabella Swetina.

Carl Aigner
Director
Kunsthalle Krems

Preface

The San Francisco Museum of Modern Art (SFMOMA) is delighted to collaborate with the Kunsthalle Krems on the presentation of more than eighty works by Paul Klee drawn from the Djerassi Collection.

The current exhibition, which this publication documents, provides the unprecedented opportunity for this collection to engage and inspire an entirely new audience. We thank our partners in this enterprise, most especially Carl Aigner, Director of the Kunsthalle Krems, and Julia Kordina, Head of Exhibition Management, for their enthusiasm and commitment to bringing this work to Krems, Austria. This collaboration was largely conceived and supported by Carl Djerassi himself, who has a special interest in seeing his collection displayed in the country of his own birth. We are equally pleased that this publication incorporates recent scholarship on the works undertaken by the Paul Klee-Stiftung, Kunstmuseum Bern.

My own involvement in this project has been personally meaningful as well, for it marks the first opportunity I have had to work with the collector, whom my father—a chemist—has known professionally for many years. As my father remarked to me recently, Dr. Djerassi is perhaps best known for his work in the field of chemistry, but he is recognized far beyond this community for his protean contributions to world peace, to science, to public health, to art connoisseurship, and to the fields of fiction and drama. Like the artist whose work he collects, Carl Djerassi is a man of many interests—and talents.

Ruth Berson
Acting Co-Director
San Francisco Museum of Modern Art

Essays

The Djerassi Collection
at the San Francisco Museum of Modern Art
Janet Bishop

As Carl Djerassi so elegantly relays in this volume, it was on a trip to London in 1965 that he first saw and purchased works by the Swiss-born modernist Paul Klee. What he did not realize at the time was that these first two acquisitions would form the genesis of one of the largest and most significant holdings of works by Klee in North America and indeed worldwide. Collecting art was not new to Djerassi, a professor of organic chemistry at Stanford University, whose accomplishments include the first synthesis of a steroid oral contraceptive, for which he was awarded the National Medal of Science and elected into the National Inventors Hall of Fame. He had begun by acquiring primarily pre-Columbian art, having become attracted to the forms while working in Mexico during the 1950s.

Over the course of thirty-five years of astute and dedicated collecting, the Djerassi Paul Klee Collection has grown to about one hundred and forty works that fully span the artist's career, from a deftly articulated river view executed during his days as a secondary-school student (*Untitled*, 1895, cat. no. 1) to others made in 1940 shortly before his death. The Collection represents a range of media—from painting on linen to work on plaster—although the majority of works are on paper, divided in number between prints, drawings, and watercolors.

This collecting activity has greatly benefited the San Francisco Museum of Modern Art (SFMOMA) and its visitors since 1984, when Djerassi made an extraordinary promised gift to the Museum of the bulk of his Klee holdings. It was also agreed at that time that a selection of these works would be on continuous display in what would be called the Paul Klee Study Center, a gallery at SFMOMA dedicated exclusively to the presentation of Klee's work. Since that time, the curatorial staff has been able to draw from the Djerassi Collection, as well as from the Museum's holdings of other Klee works, to present varying aspects of the artist's production on an ongoing basis. To date, the Djerassi Gallery/Paul Klee Study Center has offered twenty-five exhibitions showcasing the tremendous breadth and richness of the Djerassi Collection.

The presentation of the Djerassi Collection at SFMOMA was initiated with a show of twenty-one works from a collection that then numbered seventy-nine pieces. This inaugural exhibition was installed in the Museum's former quarters in the War Memorial Building on Van Ness Avenue (fig. 1) in what was known as the New East Gallery. In the ten years that followed, before the Museum moved to its current location on Third Street, the New East was the site for another ten presentations of Klee's work, ranging from examinations of the different stages in the artist's career to explo-

[1]
From 1935 until 1994, SFMOMA operated in a building at 401 Van Ness Avenue in San Francisco's Civic Center.

rations of his myriad subjects, styles, and techniques. The architectural program for SFMOMA's present Museum building (fig. 2) which opened in January 1995, called for specially designed galleries for the permanent collection, including an intimate space—the Djerassi Gallery/Paul Klee Study Center—dedicated to rotating presentations of the small-format works of Paul Klee. Adjacent to galleries devoted to other European modernist works, this gallery allows Klee's *œuvre* to be seen at once monographically and in the context of that of his contemporaries, with interruptions in this program prompted only by special circumstances, such as the present exhibition of the Djerassi collection in Europe.

Curiously for an artist popularly known for childlike imagery and whimsy, one of the most distinctive aspects of Klee's work is its complexity. Klee (like the West Coast chemist-novelist who so enthusiastically collects his work) might have been described as a focused individual with broad interests. Art, music, literature, science, nature, and philosophy all captivated the artist over the course of his forty-year career. Klee's work became a sort of laboratory—a place to distill these interests and test, in visual form, his observations of the natural and social world around him through various approaches to pictorial language. His perpetual inventiveness led not only to remarkable diversity within an *œuvre* of over nine thousand objects but to layered individual works, often evocatively titled, that invite multiple interpretations.

Indeed, it is what Djerassi calls Klee's «intellectually polygamous nature» that first attracted him to the work and that continues to stimulate and inspire him. The collector notes that in Klee he found a true affinity with an artist «engaged or interested in many different things concurrently both in his professional life and in his social life … an equal tendency I have found in my own life.»[1] Like Klee, Djerassi—who was born in Vienna in 1923 and emigrated with his mother to the United States in 1938—focuses his own intense energies on a diverse range of subjects. Though still a professor of chemistry at Stanford University—the appointment that first brought him to the Bay Area—he now spends a great deal of time writing and has, in the last decade, published five novels and two autobiographies, as well as numerous poems and short stories. An essay from Dr. Djerassi's latest book, *This Man's Pill: Reflections on the 50th Birthday of the Pill* (2001), is included in this volume; he is currently working on a trilogy of plays, two of which have already been staged and translated into five languages.

Over twenty years ago, Dr. Djerassi made a crucial decision to sell or give away all of the works of art in his collection created by deceased artists (Degas, Dubuffet, Giacometti, Marini, Moore, and Picasso, to name a few) and to focus instead on the support of living artists through the establishment in 1979 of the Djerassi Resident Artists Program.[2] The one artist whose work he refused to give up was Paul Klee. Rather than

1 Telephone conversation with Kelly Purcell, 27 October 1997.
2 Some 1200 artists have now been in residence at the Djerassi Resident Artists Program on the site of Dr. Djerassi's former ranch near Woodside, California. (www.djerassi.org)

curb his collecting pace, Djerassi determined at that time to build a major collection of Klee's work, a significant commitment that will continue to have an impact for the rest of his life and leave a lasting legacy in the art world.

By making the works in his collection available to SFMOMA either by extended loan or by gift, and by promising to donate most of his Klee holdings to the Museum, Carl Djerassi has transformed what began as a private indulgence into an infinitely valuable public resource. Such undivided attention on the part of an individual to the work of this one artist enriches the San Francisco Museum of Modern Art and makes the San Francisco Bay Area a pilgrimage site and center for the study of this exceptional modernist.

[2]
SFMOMA's current building, designed by Swiss architect Mario Botta, opened in January 1995.

The Genesis of a Passion

Carl Djerassi

In my college days, I had seen reproductions—on postcards, calendars, posters, catalogues, and art books—of Paul Klee's most famous works, like the *Twittering Machine* or *Ad Parnassum*. Subsequently I saw many of his oils, drawings, and watercolors in museums in Europe as well as in America. In the mid-1960s, I went to my first Klee show in a gallery in London, where all of the works were for sale. I kept returning to two magnificent watercolors from his Bauhaus years in the 1920s—rather large ones for an artist who usually worked on a small scale. «Should I? Can I?» I asked myself, and realized for the first time that I actually might be able to afford one of them. Finally, I approached one of the gallery employees and asked about the price. «The 1925 *Horse and Man*?» he asked, looking me up and down. «Sixteen,» he finally said.

«Sixteen what?» I wanted to ask, but didn't. I knew it could not be 1,600, and was unlikely to be 160,000, so it had to be 16,000. But sixteen thousand what? Dollars, pounds, or even guineas? «And the other one, the 1927 *Heldenmutter*?» I asked hesitantly.

«Eighteen.»

«Hm,» I replied and went back to look at the pictures. A few minutes later, the man appeared by my side. «Which one do you prefer?» he asked in a slightly warmer tone.

«I can't make up my mind. Both are superb.»

«Buy them both,» he said matter-of-factly, «and maybe we can arrange a better price.»

Bargaining, whether in a marketplace in Mexico or a bazaar in Cairo, always makes me uncomfortable; but this time I haggled like a rug merchant. Every retreat of mine, every inspection and reinspection of first one and then the other Klee caused the price to drop. They were not big reductions, but given the overall sums—far above anything I had ever spent before on art—they were not insignificant. Finally, I said, «I'll have to think about it.» A couple of days later, I was the owner of two Klees. Even now, after decades spent collecting Klee in all his various media, these two are still among the *crème de la crème*.

My purchase of these first two watercolors was exhilarating for me, but at the time I had no idea if it was merely a fling, or the beginning of something more serious. All doubts on that point were resolved with the acquisition of my third. I saw it on the walls of the Guggenheim Museum; it appeared with the notation «Collection Galerie Rosengart.» It did not take me long to secure the address of that gallery in Lucerne, or to consummate by mail the purchase of that small gem—a description I learned eventually that Klee himself agreed with. Galerie Rosengart was owned by a father-daughter pair, Siegfried and Angela Rosengart, among the most important dealers and col-

Reprinted from Carl Djerassi, *This Man's Pill: Reflections on the 50th Birthday of the Pill* (2001), pp. 217–28, with kind permission of Oxford University Press.

lectors of Klee's works. Eventually I got to know them well, and made frequent pilgrimages to their gallery. A couple of years after I bought the watercolor off the Guggenheim walls, Rosengart *père* told me the significance of the small notation «S Cl» which Klee had marked in pencil in the lower left-hand corner of that watercolor. An abbreviation for *Sonderclasse*, «special class,» it denoted his own favorites among over nine thousand works. I later learned that Klee had marked earlier works «S Kl,» until someone told him that spelling *Klasse* with a C had, so to speak, more class.

A few years later, I expanded my collection to include Klee's graphics, of which there exist only about one hundred. The early ones, done between 1901 to 1905, are Klee's first truly original creations and also among his rarest. He called them «inventions,» and titled them ingenuously, such as the famous 1903 «sour» print, *Two men meet, each believing the other of higher rank*. Their inherent sarcasm; their bizarre portrayals of the human figure; even their frequent perversity—these are some of the reasons why I continue to search for additional works from that period. In the middle 1970s, there was a major auction of Klee graphics in Bern, where Klee spent his last years, where his son Felix lived until his own death, and where, within the walls of the Kunstmuseum, the Klee Foundation is situated. By that time I knew most of the important Klee dealers as a customer and, in a couple of instances, as a friend. I had studied the auction catalogue and carefully examined the lots prior to the start of the auction. I had a mental art budget for the year, which promised—with luck—to suffice for the purchase of two of the early graphics. At an auction, however, one never knows. All it takes is for two people to become enamored with the same lot, and the price heads for the stratosphere.

I informed two of the dealers I saw in the audience that I was going for these two etchings; although I could not ask them openly not to bid in competition with me, I was reasonably sure that they would not drive the price up once they knew of my plans. But then my heart sank. In the distance, I saw Heinz Berggruen (then an important art dealer in Paris), who, I knew, not only had a magnificent personal Klee collection but bid actively at auctions. I approached him and, after exchanging the usual pleasantries, mentioned the two lot numbers I planned to bid on. «Good choices,» he acknowledged. «I was thinking of buying these for the gallery.» There was no question about Berggruen's ability to outbid me any time, but he must have read the disappointment in my face, for he offered to bid for me, saying he would just charge me a commission for any successful bids. I accepted immediately, thinking that such a commission was a bargain insurance premium in return for not having the art dealer as a competitor. I left the auction in shock. Under Berggruen's whispered persuasive urging I had bought not two, but seven Klees, blowing in minutes my art budget for five years. Yet I have never regretted following his advice. Several of the prints I bought have never again appeared at sales; and although I bought the prints purely for delight, my pleasure is not tainted by the fact that they have increased greatly in value. At the auction,

Berggruen pointed out to me a man sitting behind us, whom we had outbid, as Felix Klee, the painter's son. Two years later, I visited him in his flat in Bern and saw his extraordinary collection, which included puppets his father had made for him—a genre of Klee until then unknown to me. He also showed me his mother's guest book. The first entry was Vassily Kandinsky, who did not just inscribe the book but drew a colored picture on that page. Not to be outdone, many of the other guests—Lyonel Feininger, George Grosz, and others I do not remember—did likewise. It is one of the most intimate and exquisite documents of European art of the 1920s and 1930s.

Both auctioneers and collectors can tell all kinds of auction stories—amusing, bizarre, dramatic, occasionally even tragic. I have written an entire short story around one episode, a story entitled «The Futurist» that eventually became the title of my first published collection of short stories. But I have never described publicly the story of a Klee purchase I made at a Sotheby's auction in London while stark naked. For reasons of convenience and anonymity (even at the risk of interrupted sleep) I prefer to bid at auctions over the telephone. Given the 8-hour time difference between San Francisco and London, I have on occasion been awakened around 3.00 a.m. to bid for an item in a sale conducted at a civilized morning hour in London. On this particular occasion, Sotheby's had notified me that they expected the Klee I was after to come up for bidding around 3.30 in the afternoon, London time. This is about the time I start each morning with 30 minutes of exercise on my cross-country skiing machine—one of the few forms of strenuous exercise I can do with my stiff left knee (fused from a skiing accident)—and I always do so naked before showering. It was barely 7.00 a.m. when, still puffing and sweating, I was called away from my exercise machine by the insistent ringing of the telephone. The Oxbridge accent on the phone apologized for calling half an hour early, but the auction had progressed more rapidly than anticipated. I was panting heavily, which the man surely took for excitement. The moment bidding started on «my» Klee, I impatiently panted «yes … yes … yes.» I soon found myself standing, sweating, shivering, stark naked, engaged in a *mano a mano* struggle with an invisible counterbidder across the Atlantic. Under the circumstances, it is perhaps not surprising that the bidding progressed at an exceptional speed to an unanticipated height: I had somehow lost my usual knack for waiting until the last moment before raising my bid. Still drenched in sweat, but now thoroughly chilled, I slammed down the phone the moment I had heard the final knock of the auctioneer's hammer to turn on the hot water in the shower.

How deeply Klee is woven into the fabric of my life is suggested by the truly unique set of coincidences that accompanied my acquisition of his *Schläfriger Arlecchino* (Sleepy Harlequin, cat. no. 75), a delightful *gouache* of 1933. The work did not sell at a 1995 autumn auction at Christie's in New York, whereupon I made a serious, though lower, offer to the owner, which was accepted after some minor haggling. I was pleased by my newest acquisition and promptly hung it by the entrance to my

study; every time I headed to my computer I looked affectionately at my sleepy harle-quin. A few weeks later, I flew to New York for a *tête-à-tête* with two editors from Penguin, whom I had never met before, about the forthcoming paperback publication of my second novel, *The Bourbaki Gambit*. The telephone message on my answering machine identified the restaurant for our lunch meeting as «Arlecchino» in lower Manhattan. A good omen, I thought, as I bade goodbye to my own Arlecchino on the way to the airport.

I was a few minutes early for our 12.30 appointment at what I was convinced would be my «lucky» restaurant. When I arrived, I found the place deserted. This could have been understandable in Madrid, where lunch starts at 3.00 p.m., but surely not in New York. «I'm afraid we're closed today,» the sole employee of the establishment announced, «the chef is sick.» «Impossible,» I countered, with all the arrogance of a proud though hardly best-selling author, «I have an appointment with my editors from Penguin.» Somehow, I thought that the plural would impress him, but my conceit was promptly punctured by the announcement that the senior editor had just phoned, claiming to be sick, and that the junior member of the team would be late. When the latter arrived, the Arlecchino employee took pity and suggested a supposedly good Italian restaurant whose name I have long forgotten. My Penguin host and I started for the new location, but as soon as we turned the corner, I saw a sign for another estab-lishment, «Rocco's.» «We've got to go there,» I exclaimed. As soon as we had sat down, I asked the *maître d'* to look at what I was fishing out of my briefcase. It was the bound galleys of my next novel, *Marx, deceased*, that I had brought along to show to the Penguin editor. Puzzled, the *maître d'* looked at the cover of the elegant Magritte painting showing a double-faced man. «Why are you showing me that?» he asked. «It's a novel,» I said. «I wrote it. Just read the first few sentences.»

One look at the opening sentence changed his expression:

«Rocco's.» The voice on the telephone was brusque, the «r» rolling like
a Ferrari in first gear.
«I'm calling about a dinner reservation,» he said. «For two. Next Thursday,
7 o'clock.»
«Name?»
«Marx.»
«Spell it.»
God, not again, he thought. It's just a four-letter word.

«Amazing,» the *maître d'* said. «Now, are you ready to order?» I waved away the proffered menus. «Just tell us what your special is for today's lunch.» «Gnocchi,» the man replied. It was my turn to look flabbergasted. «I don't believe it,» I said as I turned to page 7 of my novel. «Just read this:

‹*The gnocchi on Marx's fork had nearly reached his mouth, but at the last*
moment he put it down.›»

By now, I was ready to believe in predestination, *kismet* or just plain *karma*. But alas, not even the charm of Klee-Arlecchino-Rocco-gnocchi was able to transcend the utterly poor judgment Penguin displayed in turning down the paperback rights to my most literate novel. The only balm to my hurt ego was provided by some reviews of the hardback edition, such as the *Washington Post* reviewer's impeccably perceptive «A classy, easy-reading page turner, light of heart and bright of mind ... a literary novel to be reckoned with.» Even my favorite European newspaper, *The Herald Tribune*, reprinted the review, without, however, any impact on the stony, penny-pinching Penguin operative in charge of paperback rejections.

But why collect art in the first place? At a very basic level, people collect—art, cars, dolls, matchbook covers, even other people—to fill a void. It has taken me a long time to realize that emotionally, much of my life has been occupied by such Sisyphean collecting. While still an impecunious student, I hated empty walls. I considered art, or shelves full of books, the only acceptable embellishment, because art and literature allow a degree of personal subtlety—a surprisingly accurate definition of the one who chose them—unique in this world. To this day, when I visit a new home, I judge my hosts by their walls. Bare walls, like bare minds, turn me off.

While all art collectors acquire art, not all acquirers of art are collectors; a collector's relationship with Art—with all the connotations that capital letter implies—is complex. Collecting requires a combination of knowledge and esthetic judgment that are not necessary for the simple acquisition of a work. Collectors are patrons of living artists if the latter are still living. But when the artist of the collected work is dead, and especially when the artist has been fetishized—become a name, an object of desire, a token of exchange, a whisper of immortality—then we are entering the territory of the Arts, a place where the void that the collector seeks to fill, and the ultimate redemption of that void co-exist in some ineffable relationship. I wish I could communicate in plain words just what I feel that relationship to be—but if I could, I suppose there would be no need for art, or for collectors. I can only suggest it here, by telling that I have felt it at widely disparate moments of my life. I felt it when I found myself «promising» (a word that promises a great many things) my Klee collection to the San Francisco Museum of Modern Art, and felt that I had become a kind of patron of the Arts.

Admittedly, my own definition of art collecting is somewhat narrow. I am not referring to the purchase of occasional pieces of art, or to collecting as investment. I am thinking of the person who concentrates on a specific artist, a specific art movement, or imposes on himself some other more-or-less arbitrary criterion; who renders an intellectual judgment and to that extent places a personal signature on the collection. Assembling five Picassos at random is very different from deliberately selecting five Picassos to make a specific esthetic, intellectual or personal point about the artist. Collecting the works of dead artists becomes a form of patronage only when it serves

the public benefit. In many respects, the serious collector of a dead artist's work also becomes that artist's curator. If one takes this role seriously, then such collecting can become an exciting creative process: one presents a special view of the artist by selecting specific aspects of that artist's work. At the same time one can do something for art appreciation and enjoyment by a wider public—as well as influence developing artists—by sharing that collection. I have always deemed it unfitting when a person with the means of amassing a substantial collection—especially of a single artist's *œuvre*—retains it for purely private gratification. Some years ago, I decided that the bulk of my Klees should go to a public museum. That conviction, in turn, has provided an additional—now, didactic—motivation to my on-going attempts to fill certain chronological or artistic gaps in my collection.

None of Klee's works is large—usually measured in inches, not feet—yet each is full of complexity, as befits the ultimate master of the *petit format*. This is incidentally another aspect of Klee's appeal for the obsessive collector: I can always find wall space for one more jewel. In fact, the size of Klee's works requires intimate space, and intimate space immediately leads to intimacy of another kind: close inspection of the work, attention to detail, and—the ultimate punctuation mark—the gasp of delight. It was the San Francisco Museum of Modern Art's promise to provide such permanent exhibition space which led me to offer the bulk of my collection in the form of a promised gift—my token of appreciation to my adopted home city. «Home city» has special resonances to an immigrant and onetime refugee—a feeling hardly unfamiliar to Paul Klee, who himself was never totally accepted by the two countries where he spent his life.

The Imaginary and the Invisible – Notes on Paul Klee: the Man and his Work
Carl Aigner

Music for me is like a lost/lover./
Fame as an artist??/
Writers, modern poets? Bad joke./
So I have no occupation, and loaf around./

With these words, a journal entry for 1898–99, written when he was nineteen, Paul Klee touches on the development of his identity as an artist.[1] That the young man should make his state of mind known in this way is less remarkable than that we see here already the diversity and the complexity that were to characterize his future creative work. It is an approach we might describe today as «interdisciplinary» or «boundary-straddling.»

Born in 1879 in Münchenbuchsee, near Bern, Klee grew up in a musical family. His father taught music. His mother had been trained as a singer. At an early age Klee learnt to play the violin, was considered a potential virtuoso, and he was a member of the Bern symphony orchestra. Not until summer 1898 did his uncertainty whether to follow music or painting come to an end, when he opted for the latter. His journal notes of the period contain reflections on painting and the visual arts that would occupy him continuously until his death: «Increasingly, parallels between music and the pictorial arts are forcing themselves upon my mind. Yet no analysis succeeds. For sure, both arts are temporal, that could be easily demonstrated,» he wrote in 1905.[2] A further significant perspective comes to light in this fruitfully tense relationship between music and painting, namely, Klee's self-reflexive, theoretical scrutiny of his position as a painter, and the knowledge accruing from it, themes that likewise accompanied his creative labours to the end of his life.

Klee's journal entry touches on a further point, namely, literary matters. Often enough Klee's titles are a kind of short poem or miniature in their own right: poetic metaphors, parallel lyrical worlds that accompany and contribute to shaping his entire *œuvre*. Just how intensely the literary component—work with and on language—interested him right into the 1930s is clear from the poems discovered after his death in 1940. They may be defined as poetic fragments, nature poetry, and texts on relationships. These remarkable epistemological reflections concern not only highly subjective states of feeling and mind, however, but also his standpoint as an artist, as when in 1920 he writes:

I cannot be understood at all on this earth.
For I live as much with the dead

1 *Paul Klee. Tagebücher 1898–1918*, new revised edition, ed. Paul-Klee-Stiftung, Kunstmuseum Bern (Stuttgart: Verlag Gerd Hatje, 1988). [English edition: *The Diaries of Paul Klee, 1898–1918*, ed. Felix Klee (Berkeley and Los Angeles: University of California Press, 1964).] The diaries, which were never intended by Klee for publication, give a revealing, subtle glimpse into his early artistic development until his first taste of success. For Klee's life and work, see the narrative biography by Will Grohmann, *Paul Klee* (New York: Harry N. Abrams, 1954) and the analytical introduction *Paul Klee. Leben und Werk*, ed. Paul-Klee-Stiftung, Kunstmuseum Bern and New York Museum of Modern Art (Ostfildern: Hatje Cantz Verlag, 2001).
2 Cited in Hajo Düchting, *Paul Klee. Malerei und Musik* (Munich, London, New York: Prestel-Verlag, 2001), 9.

Paul Klee with his *Bergbahn* (Mountain railway), 1939

as with the unborn.
Somewhat closer to the heart of Creation than usual.
But not nearly close enough.[3]

The poem impresses not only because of its «metaphysical» tone. It is also a succinct credo and summary of his artistic position, which at this point in time had shifted definitively from representation to abstraction. In 1913 he translated a text by Robert Delaunay, where we read: «As long as art remains tied to objects, it remains description, literature; by employing inadequate means of expression it lowers itself, damns itself to being slavish imitation.»[4] Klee's encounter with Delaunay in Paris in 1912, his friendships with Kandinsky dating from 1911 and with the Blauer Reiter (Blue Rider) painters August Macke and Franz Marc, all entailed a significant *caesura* in the development of his artistic identity.

As early as 1890, after his first juvenile drawings, Klee experimented in works dealing with his immediate surroundings—first and foremost the countryside around Bern—and human caricatures that are both *art nouveau* in style and imitative of classical forms. They mark the start of an immense pictorial *œuvre* comprising some nine thousand works at his death. In 1903 he began his first etchings, which show a strong literary bias; in 1905 he began drawing and painting on glass.

A relative loosening of formal constraints is apparent after Klee's move to Munich in 1906, which brought him into contact with Impressionism for the first time, with Van Gogh and above all Cézanne. His first diffident experiments with color, a probing of tonalities, characterize this period, as he explored the potentials of watercolor. But before meeting the artists of the Blauer Reiter and especially his trip to Tunis with Macke and Louis Moilliet in 1914, which heralded a definitive breakthrough in his color works,[5] drawings predominate.[6] His cycle for Voltaire's *Candide* (1911) is a good example. «How world and art might become one is Klee's chief preoccupation at this time,» as Will Grohmann has observed.[7]

1914 through 1920, the year in which Klee was called to teach at the Bauhaus in Weimar, are the years that brought about the full ripening of his artistic identity, especially as a painter. Aside from the increasing thematic richness of his pictures, two aspects in particular define his work. First, there is a strong tendency toward theoretical reflection, which becomes admirably clear-headed and stringent. Then there is an elaboration of increasingly complex artistic techniques, a veritable explosion of them one could almost say.

Klee not only worked with new painting surfaces—diverse papers, sackcloth, muslin, wood, and cardboard; he also used integrative techniques such as oil transfer of drawings primed with water-based paste for the first time; chalk, plaster of Paris, watercolor, tempera, oils, and glazes, alone or in combination, assume a genuine, dynamic character within which Klee's uniquely pictorial world unfolds. Since he pro-

3 Paul Klee, *Gedichte*, ed. Felix Klee (Zurich, Hamburg: Arche Verlag, 2001), 7.
4 Cited in *Paul Klee. Kunst–Lehre*, ed. Günther Regel (Leipzig: Reclam, 1987), 59.
5 See *Paul Klee. Reisen in den Süden*, ed. Uta Gerlach-Laxner and Ellen Schwinzer (Ostfildern: Gerd Hatje Verlag, 1997).
6 For the drawings and watercolors, see Jürgen Glaesemer, *Paul Klee. Handzeichnungen I: Kindheit bis 1920* (Bern, 1973), *II: 1921–1936* (Bern, 1984), *III: 1937–1940* (Bern, 1979); Siegfried Gohr, *Paul Klee. Das Werk der Jahre 1919–1933. Gemälde, Handzeichnungen, Druckgraphik*, exh. cat. (Kunsthalle Köln, 1979).
7 Grohmann (n. 1), 121.

duced his *gesso* and other materials himself, his workplace resembled a chemistry laboratory more than an artist's studio.[8] The experimental and the elevation of the materials themselves to subject status, two fundamental traits of Modernism, are in evidence here no less than the conception of artistic labour as process, a strategy one would refer to nowadays as «cross-over.»

No other twentieth-century artist exhibits quite such a store of creative richness as Klee in whose *œuvre* traditional divisions such as «drawing,» «painting,» «work,» «panel» cease to hold. His exploration of new terrain, such as innovative design; his resolute break with representation as a too one-dimensional view of things, in place of which he set pictorial polyphony and polysemy; by such means he helped equip Modernism, or the *avant-garde*, for renewal and redefinition that could not have been more radical.

Few artists can have devoted such precise, detailed thought to the creation of their works as did Klee. In this respect he proved an important theoretician and an excellent teacher of art, not least through his activity at the Bauhaus. In multifarious essays, lectures, and reviews he sketched—gradually yet systematically—the self-reflexive, theoretical space for his own artistic achievement.[9] «Der eigene Standpunkt» (My Own Standpoint, 1916), «Schöpferische Konfession» (Creative Credo, 1920), «Wege des Naturstudiums» (Ways of Studying Nature, 1923), and above all «Über moderne Kunst» (On Modern Art, 1924) are nodal points in his discursive relationship with his own creative practices. In these essays, Klee marks out his own personal position *vis-à-vis* abstraction, this fundamental shift of paradigm that is arguably the most drastic and far-reaching to have taken place since the Renaissance.

What precisely is the essence of abstraction for Klee? «Let us develop, let us—following a topographical image—undertake a short journey into the land of better knowledge,» we read in «Creative Credo.» It is not a question of realism, emotionalism, or psychology for Klee, but one of gaining knowledge beyond superficial rationality. As he explains in «My Own Standpoint»: «I adopt a distant, original standpoint, where I presuppose formulas for man, animals, plants, rocks, and the elements, for all the circulating forces at once.»

This means that, for the artist, reality is not simply the possibility of rational experience that can be immediately communicated. Rather a translation at a formal level is the creative precondition of any gain in knowledge. «Art's relation to Creation is allegorical. It provides *instances*, just as the Earth is an *instance* with respect to the Cosmos.» Partly for this reason the topic of nature is a dominant factor in Klee's work. As he expounded in 1924: «Dialogue with nature is a *sine qua non* for the artist. The artist is a human being, and is himself nature, a fragment of nature in nature's realm.» So abstraction for Klee was not a question of alienation or reduction, but of an allegorical translation and transcription on the strength of a formal—that is to say, creative or esthetic—pictorial discourse.

8 See Nathalie Bäschlin, Béatrice Ilg, and Patrizia Zeppertella, «Bei-träge zur Maltechnik von Paul Klee», in *Paul Klee—Kunst und Karriere*, ed. Oskar Bätschmann and Josef Helfenstein (Bern: Stämpfli Verlag, 2000).
9 See Regel (n. 4), from whom my quotations are derived.

10 Richard Hoppe-Sailer gives an excellent one-picture analysis of the strategy, in R. Hoppe-Sailer, *Paul Klee: Ad Parnassum* (Frankfurt am Main, Leipzig: Insel Verlag, 1993).

11 *Paul Klee. Sammlung Felix Klee*, exh. cat. (Hannover: Kestner-Gesellschaft, 1980), n.p.

12 See Regel (n. 4), 60.

13 See *Paul Klee. Vorbild–Urbild, Frühwerk–Spätwerk*, exh. cat., preface by Otto Breicha (Graz, Salzburg, Vienna: 1986).

14 See *Paul Klee: in der Maske des Mythos*, ed. Pamela Kort (Cologne: DuMont, 2000).

15 See *Paul Klee: Catalogue raisonné*, vol. I (1998), vol. II (2000), vol. III (1999), vol. IV (2000), vol. V (2001) (Wabern: Berteli).

Pictorial creation in Klee's view is composition and construction; above all «art does not reproduce the visible, rather it makes visible.»[10] «In both his art as in his life,» in the words of Carl Haenlein, «Klee illustrated the relation between production and reflection, between the artistic act and thinking about it, richly and densely. No other twentieth-century artist surpassed him in this.»[11] This helps us grasp the particular worth of the extensive graphic *œuvre* within Klee's overall *œuvre*, as also of the border-straddling nature of drawings, prints, and paintings. «Graphic art leads naturally and quite rightly to abstraction. ... The purer a work of graphic art is, that is to say, the greater the weight laid upon the graphic representation of basic formal elements, the more poorly one is equipped for depicting visible things naturalistically.»[12] It is not by chance that Klee's thoughts on graphic art—as in «Creative Credo»—hold a notable position in his theoretical writings.

The emphasis Klee accorded formal elements should not mislead us into seeing it as pure formalism. The generation of form in the process of artistic work need not exclude theme and motif; rather they are poles of a reciprocal process. Tilman Osterwold has already drawn attention to the fact that Klee always looked on existential themes in his work as creative factors.[13] Indeed, this is one of the most fascinating things in his *œuvre*—at first sight it is poetic, mythological, dreamy,[14] sometimes romantically ornate, even naïve; but the longer one looks at it, the more it reveals itself as a corpus of unbelievable precision, intellectually and intuitively exceptional, where each detail relates to every other detail. As such it stands unrivalled in the history of twentieth-century art.[15]

Interview with Carl Djerassi
Carl Aigner

Carl Aigner: Professor Djerassi, you were born in Vienna in 1923, spent a large part of your childhood there, and had to emigrate following the German annexation of Austria in 1938. Your mother was a Viennese doctor, your father, who studied medicine in Vienna, came from Bulgaria—both were of Jewish origin. This makes your parents a representative instance of Central and Eastern European history, culture, and identity. What cultural memories do you have? Had you already come into contact with the visual arts at that time?

Carl Djerassi: After leaving Austria in 1938 I didn't return again before 1957, and until early 1990 I was here three times in all. In the past ten years, I have visited Austria two or three times yearly. Of course I think about my early past, but each time it's slightly different, I romanticize it in part, for after all every autobiography is automythology. The first thing I'd like to say is that Vienna is still a museum. If you want to study art, or simply to experience it, you need only go downtown or into a museum. So, as a child, I was living in a museum and I know this had a big effect on me. In my parents' apartment there were no artworks, but there were plenty of books on art history. I'm one of those people who can't throw books out, and in my library I keep coming across German books from that time, art historical works—on Titian, Rembrandt, the Renaissance. That we chose to take such books when we emigrated, although there were doubtless more important things, is significant too.

Aigner: You opted for a career in science at a fairly early stage, when you journeyed on from Bulgaria to America, where your pioneering scientific research took place. Were the visual arts already an object of interest to you during this period, up into the 1950s, on your many trips, for example?

Djerassi: Yes, indeed. I've always taken an interest in visual art—I never visit a city without going to museums. As a student, I hung posters on my walls; one, incidentally, was a work by Klee, his *Zwitschermaschine* (Twittering Machine), which is in the New York Museum of Modern Art. It was when I was living in Mexico in 1950–51, and from 1957 to 1960, that I began collecting in earnest—pre-Columbian artefacts, as the culture interested me enormously and also because for the first time in my life I could afford it. But I was already buying contemporary Mexican art then, paintings, which were inexpensive; by the late 1950s I was earning a good income and at the start of the '60s I had already begun collecting works by Klee. It was at the noted London Marlborough Gallery, which mounted a Klee exhibition in 1963 (I still possess the catalogue), that I acquired *Pferd und Mañ* (Horse and Man, 1925, cat. no. 43) and *Heldenmutter* (Hero Mother, 1927, cat. no. 51), my first two drawings by Klee. It had not really occurred to me to buy both. It was a gallery employee who put the idea into my head

when I couldn't make up my mind. That's how I came by my first two pictures by Klee —that's how it all began. Shortly afterwards, I met Heinz Berggruen.[1] He was a dealer in Paris and he possessed exceptionally beautiful prints. Then we were at a Kornfeld auction together and he saw how taken I was by a particular Klee, but he had far more money than I had. So he made me a proposition—he would bid for me if I paid him ten percent commission. They were important, early works, prints, extremely detailed, today among the most valuable Klees there are. I bought seven works at that auction, because Berggruen kept whispering to me, «If I were you I would buy it.» I was in a state of shock! But he was right. And then in the early '70s I got to know all the important dealers who had pictures by Klee, and in a short space of time I became thoroughly acquainted with Klee's œuvre.

Aigner: What is it about Klee's pictures that fascinates you so much? You collected from an art-historical point of view, you collected modern art. What was it in Klee that so captivated you? What do you think makes his works unique?

Djerassi: In my mind he is the most intellectual painter I know, an intellectual polygamist. He was poet, musician, teacher, and he wrote textbooks. But what especially fascinates me is that he gave birth to highly intricate pictures of very small format. I find that important from an intellectual point of view—he is a master of the *petit format*. One must step right up to his pictures and allow, and develop, a specific closeness with respect to them; I like that. On top of this, Klee's working methods were highly complex. He invariably worked on several pictures at once, up to twelve at a time, and it's hard to believe, for example, that the works in my collection dated 1923/24 arose simultaneously. He could work, then, in enormous detail on utterly different pictures. Then there is the great impact he had and continues to have on other painters. I once bought a diverting picture by a German painter, Hans Reichel, who had emigrated to Paris, and died in the early 1950s. He had worked in Munich in the early '20s and he had known Klee very well. I remember once going to the big Saidenberg Gallery in New York, which owned a lot of Klees. On entering, I saw a picture that looked like a Klee some twenty metres off. But Mrs. Saidenberg told me it wasn't by Klee, but by Reichel. I liked the picture a lot and bought it, and it is still in my possession. It is called *Teppichartig* (Carpet-like, 1950) and should be compared with Klee's *Teppich* (Carpet, 1917, cat. no. 16) in my collection. Then I was in Colmar some twenty years ago, where there was a Reichel retrospective, and I saw the great affinity between these painters and the big influence Klee had had on others.

Aigner: That influence still holds today. What do you think are the reasons for it? Is it the so-called poetic aspect of his work in conjunction with his extremely precise, intricate, theoretically grounded pictorial inventiveness?

Djerassi: Yes, I think that's the essence of it. His multilayered compositions and the exactitude of his solutions are what still exert their hold. But there is another fascinating aspect: I invariably discover something new when I look at his pictures. Of course,

[1] See the excerpt from Carl Djerassi's autobiography, *This Man's Pill: Reflections on the 50th Birthday of the Pill* (Oxford: Oxford University Press, 2001), reprinted on pp. 15–20.

I'm familiar with those special features of Klee's work that all of his collectors, if not others, are acquainted with, for example the inscription «S Cl» or «S Kl» pencilled in the bottom left-hand corner of some pictures—the abbreviation for «*Sonderklasse*» (special class). It represented Klee's wholly personal taste. He marked one percent of his works at most in this way. Klee used the form «S Kl» until 1919, then changed to «S Cl.» The late Siegfried Rosengart, collector and dealer in Lucerne, once told me another dealer in Klee pictures told him Klee started using «C» instead of the no less correct form with «K» after discovering it had «more class.» Why he marked pictures this way has always interested me. All the works in my collection that bear the inscription are fantastically different. It's almost like a chemical symbol, and I'm quite certain it was not for himself Klee did this, or for other people. I often try to think myself into Klee's position—what was going on in him at the time?

Aigner: You mentioned chemistry. Does Klee's work, thanks to your profession, open up other routes to and possibilities of knowledge?

Djerassi: No, not really. There are not many artists who have had a big effect on chemists. The Dutchman M.C. Escher is an interesting exception. It's incredible how many chemists mention him in their lectures in order to illustrate stereochemistry, although there are plenty of scientists who show a lively interest in Klee, as I know from my own experience. Here, too, I often try and put myself in Klee's position. The reason, I believe, is contained in a German word that does not exist in English, and which the American poet Wallace Stevens used as the title of a poem (in English): «Lebensweisheitspielerei». This, as I see it, is the motto for many of Klee's works, which repeatedly communicate this aesthetic experience of life, wisdom, and play(fulness).

Aigner: What led you to focus on prints, drawings, and watercolors?

Djerassi: To begin with it was mainly because they were within my means. But it soon became the expression of a personal preference.

Aigner: How have you come by your Klee works as a rule?

Djerassi: Klee collectors, much like other collectors, are generally in close contact with each other, of course. What is remarkable, however, is that the few dealers who have specialized in Klee have also been Klee collectors, Berggruen, for example, Saidenberg, Beyerle, or Rosengart. Rosengart especially was interesting—each time I paid him a visit he and his daughter, Angela, would treat me to a private exhibition in his Lucerne apartment. Aside from these highly personal contacts and acquisitions, I acquired the major part of my works, as I still do, at auctions—Sotheby's, Christie's, Kornfeld in Bern, and Hauswedell & Nolte in Hamburg being my most important sources. I also receive all of their auction catalogues and so I'm kept well up to date. I've had all sorts of amusing experiences as well. For example, I once bought a Klee picture in the nude—on the telephone, of course. And my last Klee purchase, *Alter Mann* (Old Man, 1924, cat. no. 38) took place at three o'clock in the morning, since the

auction was in London and I was in California at the time. But I was very anxious to acquire the picture—it is directly related to my *oriental. [isches] Mädchen* (Oriental Girl, cat. no. 39) of the same year and month.

Aigner: You acquired a new work by Klee not long ago—do you see your collection as a kind of «work in progress»?

Djerassi: Yes, very much so. Whenever I get the chance to buy new pictures and can, I do. Altogether there exist some nine thousand works by Klee, there's always something to be discovered, and one keeps finding a few works up for sale. I'll have plenty to do for a long time. And I keep coming across pictures I'd very much like to be able to buy one day.

Aigner: You are not only a collector—you began supporting contemporary art as well in the late 1970s, when you created a Resident Artists Program. Is there any connection here with your passion for Klee?

Djerassi: No, none at all. It has more to do with the death of my daughter, who was herself an artist, and with the artists' colony near San Francisco or at least with the trust I founded in 1979. At the time, I was collecting works by sculptors and painters such as Picasso, Giacometti, Degas, and Moore, all non-living artists. Later, I told myself that I could no longer do anything for deceased artists, so I sold all the works I had by artists who were already dead. It was a traumatic experience—the death of the one artist who meant more to me than any other, my own daughter—that caused me henceforth to dedicate myself exclusively to living artists. The sole exception I made was Klee.

Aigner: In this connection you also began considering what was to become of your Klee collection. How did the arrangement with the San Francisco Museum of Modern Art develop, and when did you finally decide on that course?

Djerassi: To begin with I wanted to donate the collection to the Stanford Museum—it is a beautiful, academically orientated museum, and also, through my work at Stanford University, I'd had connections with the museum for many years; I already had some sixty Klee pictures then, and it was impossible for me to keep them all at home. It was important to me then, as now, for the pictures to be publicly accessible rather than gathering dust in a cellar somewhere. Whatever my misgivings on conservational grounds, the pictures, as I see it, are there to be viewed now and not in some temporal framework of centuries! But the Stanford Museum put them in storage, and then one day I said they had to come out again and be hung somewhere where they could be exhibited and seen. I began looking around for a museum that would guarantee to exhibit the pictures as well as to equip a special, intimate Klee room, where the pictures could be on permanent display. I established contact with the San Francisco Museum of Modern Art, my ideas became reality, and in 1984 the contract was signed. Another important factor was that, aside from the big Klee collections on the east coast and in Chicago, there would now be—alongside the Galka Scheyer Collection on The

Blue Rider in Pasadena—a second important collection in the west. That Mario Botta, the Swiss architect who designed the museum building in San Francisco, took on this Klee room from the start as a particular challenge, was a further, fortuitous circumstance.

Aigner: If at the beginning of the 1980s Austria—the Albertina, for instance—had expressed an interest, would you have considered donating your pictures to Austria?

Djerassi: No, and for a very simple reason. My relations to Vienna have been complicated—right up to the 1990s there was no contact at all, I was never invited, and as far as the Viennese were concerned, after being thrown out of their country in 1938, I had ceased to exist. In the past ten years, however, I have been to Vienna very frequently, although not to the rest of Austria, and new ties, emotionally as well, have arisen. Were someone to ask me today, then, yes, it might be possible, if it weren't for the prior agreement with the San Francisco Museum of Modern Art. Being unfamiliar with the situation in Vienna and Austria, I can't say what museums would be eligible. You are the first person to ask me the question, and any answer is anyway purely hypothetical.[2]

2 Professor Carl Djerassi was awarded the Austrian Cross of Honour for Science and Art in 1999.

Catalogue

All German titles are Klee's, as recorded directly on the works of art and/or in his personal *catalogue raisonné*. Deviations from standard spelling are his and have been preserved.

The Authors
JB Janet Bishop
JSW John S. Weber
KP Kelly Purcell

1. *Untitled*
1895
pen and ink on gold-edged paper
3 x 4 3/4 in. (7.6 x 12 cm)

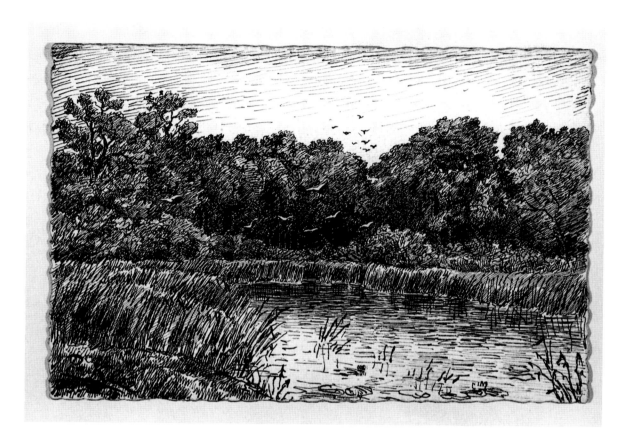

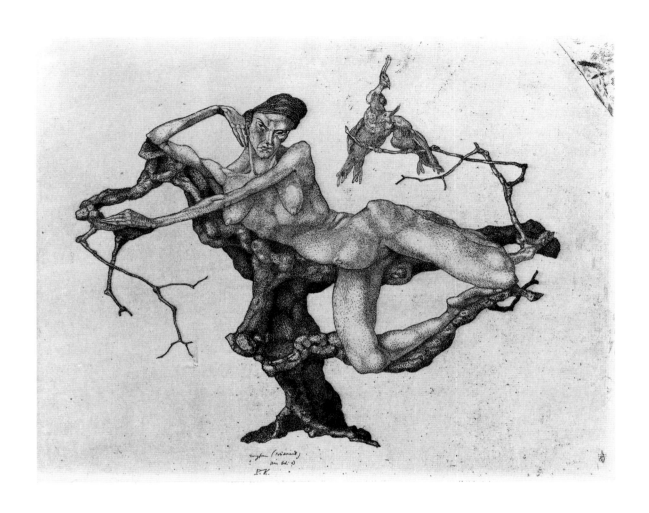

2. *Jungfrau (träumend)*
(Virgin [dreaming])
1903, 2
etching on zinc
9 1/4 x 11 3/4 in. (23.6 x 29.8 cm)

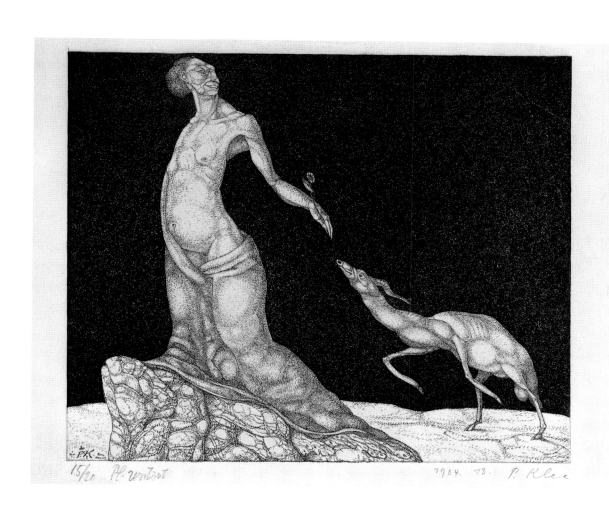

3. *Weib u. Tier (Invention 1)*
(Woman and Beast [Invention 1])
1904, 13
etching on zinc
7 7/8 x 9 in. (20 x 22.8 cm)

4. *Greiser Phönix (Invention 9)*
(Aged Phoenix [Invention 9])
1905, 36
etching on zinc
10 5/8 x 7 3/4 in. (27.1 x 19.8 cm)

5. *Drohendes Haupt (Invention 10)*
(Threatening Head [Invention 10])
1905, 37
etching on zinc
7 x 4 7/8 in. (17.8 x 12.5 cm)

1 *Diaries*, 168, entry 602.
2 Letter to Lily Stumpf, 19 February 1905, in Klee, *Briefe*, vol. 1, 482. For full discussion of the political implications of the image, see O. K. Werckmeister, «From Revolution to Exile,» in Lanchner, *Klee*, 40–41, 47.
3 Letter to Lily Stumpf, 20 March 1905, in Klee, *Briefe*, vol. 1, 489.
4 *Diaries*, 168–69, entries 602–3.
5 For discussion of Klee's interest in the relationship between brain and fist, see Franciscono, *Klee*, 52 and 340 n. 143.
6 Felix Klee, «My Thoughts about the Prints of Paul Klee,» in *Graphic Legacy*, 16.

In 1903 Klee started a series of *Inventions*, collectively known as *Opus I*, which would result in his first significant artistic output. Comprising eleven etchings primarily of busts and single figures, these highly exacting works reveal both the artist's assimilation and rejection of his academic art training (which had included anatomy lessons and life drawing), as well as his considerable graphic abilities. Above all, these etchings, rendered in what he called his «sour» style, provided a biting commentary on social conventions, human nature, and the plight of contemporary existence.

The final two works in the series were *Greiser Phönix* and *Drohendes Haupt*. In *Greiser Phönix*, Klee presents a figure ambiguous as to both species and gender, a cross, as the artist wrote, between «realism and fable.»[1] The figure is essentially human, but significant parts of the body—hands and head—are clearly birdlike. At the outset of the project, Klee explained his intent to present the rebirth of the phoenix: «One has to imagine, for example, a revolution has just happened; they have burned inadequacy and it reemerges, rejuvenated, from its own ashes.»[2] However, the resulting image, as the title indicates, is a portrait of the phoenix as «extremely decrepit and close to the end.»[3] Though still standing erect, chest pushed forward and head thrown back, the ancient creature has lost one foot, most of its feathers, and thus the ability to move, either on land or by air. As in other works of this period, the artist's emphasis is on decay and degeneration.

On 20 March, the day he first printed *Greiser Phönix*, Klee acknowledged the event in his diary, then wrote, «Now comes 'The Threatening Head'; I am almost inclined to believe that this will be the last print in the strict style and that something entirely new will follow. … The end is gloomy enough. Some destructive thought or other, a sharply negative little demon above a hopelessly resigned face.»[4] While the *Greiser Phönix* is doomed by its circumstances, *Drohendes Haupt* bears the potent expression of internal anguish, the antlered rodent sitting upon his head functioning as a symbolic extension of a brain clenched as tightly as a fist.[5] As the last print in the series, *Drohendes Haupt* is the only fully frontal work. With furrowed brow, large dark eyes, and a screwed-up mouth, the face, as the artist's son, Felix Klee, pointed out, bears the features of a self-portrait,[6] the plausibility of which is heightened by how carefully Klee must have scrutinized the possibilities of human facial expression as he made the print. JB

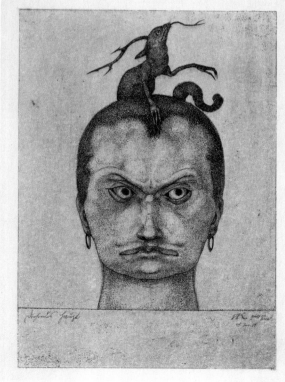

6. *Der Held mit dem Flügel*
(The Hero with the Wing)
1905, 38
etching on zinc
10 1/8 x 6 1/4 in. (25.7 x 16 cm)

7. *Weibl. Figur, bäurisches Kostüm,*
von hinten, eine Hand erhoben
(Female Figure, Peasant Costume,
from Behind, One Hand Raised)
1906, 10
pen and ink and wash on paper
mounted on board
8 3/8 x 8 5/8 in. (21.3 x 21.9 cm)

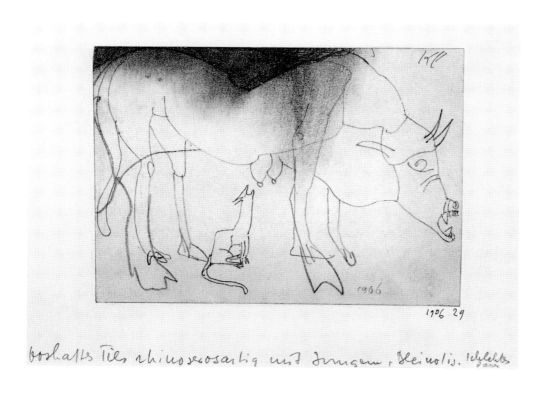

8. *Boshaftes Tier, rhinozerosartig
mit Jungem*
(Malevolent Animal, Rhinoceros-like
with Calf)
1906, 29
graphite and pigment on paper
mounted on board
3 1/2 x 4 3/4 in. (9 x 12.2 cm)

9. *Sechs Akte, «Empfindungen*
Spazierender»
(Six Nudes, «Strollers' Sensations»)
1908, 3
pen and ink and graphite on paper
mounted on board
6 7/8 x 8 5/8 in. (17.5 x 22.1 cm)

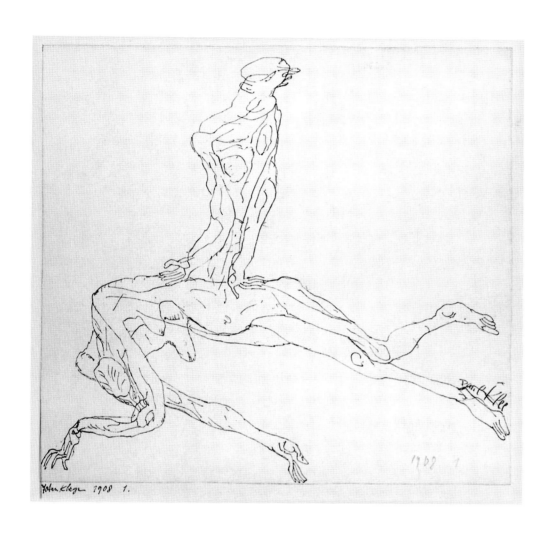

10. *Toten Klage*
(Lamentation of the Death)
1908, 1
pen and ink on paper mounted
on board
7 1/2 x 8 1/4 in. (19 x 21 cm)

11. *Studie nach e. männlichen Modell (Durchgeistigung durch Primitivität)* (Study of a male model [Spiritualization through Primitiveness]) 1909, 67
charcoal, pen and ink, chalk, and graphite on paper mounted on board
12 1/8 x 9 in. (30.8 x 22.9 cm)

7 In 1906, a friend of Klee, the artist Ernst Sonderegger, became a source for the graphic art of James Ensor. For a chronological account of Klee's contact with the work of various post-impressionists, based largely on information contained in *Diaries* and Klee, *Briefe*, see Franciscono, *Klee*, 102. See also *Diaries*, 219, entry 804, 224, entry 812; and Jürgen Glaesemer, *Paul Klee: Handzeichnungen I: Kindheit bis 1920* (Bern: Kunstmuseum Bern), 138–39.
8 Haxthausen, *Klee*, 256–57. See also *Diaries*, 222, entry 812.
9 For a brief discussion and several illustrations, see Franciscono, *Klee*, 100–103.
10 *Ibid.*, 102.
11 From 1908 to 1911, Klee worked primarily from nature. See *ibid.*, 97.
12 *Diaries*, 238, entry 859.
13 *Ibid.*, 221.

During the early part of the twentieth century, Munich emerged as a center for international art with a multitude of venues offering the latest avant-garde trends. A resident of the city since 1906, Klee incorporated aspects of French impressionism with myriad styles of post-impressionist artists, particularly Paul Cézanne, James Ensor, and Vincent van Gogh. According to Klee's various diary entries, there were numerous opportunities for him to gain an understanding of their work, ranging from the publication of Van Gogh's correspondence and Ensor's prints to solo shows of Van Gogh at Brakl's and Zimmermann's galleries in 1908.[7] Frustrated with the direction of his own work, the artist eagerly experimented with the new techniques, resulting in a period from 1908 to 1910 that he regarded as his most «impressionistic.»[8] This drawing testifies to Klee's thoroughly idiosyncratic interpretation of this style and further provides a harbinger of the prolificacy that would define his career.

The subject, a likeness of an elderly mustachioed and bearded man, is hardly unconventional in the context of a number of figure studies by Klee dating from the same general time.[9] Though the sitter remains unidentified, Klee probably represented a particular individual, given that «his portrait studies … have an interest that comes from the shrewd observation of character.»[10] In addition, the lack of caricatural treatment points toward the supposition that the artist worked from nature.[11] As Klee's intended meaning cannot be gauged by pictorial content alone, a consideration of the title adds an enigmatic element to an otherwise traditional depiction. Far from offering an explicit reading, the title casts a mystical veil over the work—Klee possibly comments on the man's state of mind or on the «primitive» yet enlightened state some people attain as death nears.

Technically, the work is indicative of a period of initial experimentation with color and tone, illustrating inchoate abilities, far from a masterful command. As Klee explained of another work, «I scattered different spots as parts (tones) of the color harmony over the entire canvas, gathered them into figures, partly with the help of the contouring line.»[12] The linear component, however, still largely determines the imagery and produces what sense of volume there is. With apparent frustration, Klee admitted, «Sometimes color harmonies take hold of me, but then I am not ready to hold them fast, I am not equipped.»[13] Despite the self-professed deficiency, the color, loosely applied here in broad, diffused masses, results in a surprising airiness appropriate for a more spiritual perception of the portrait. KP

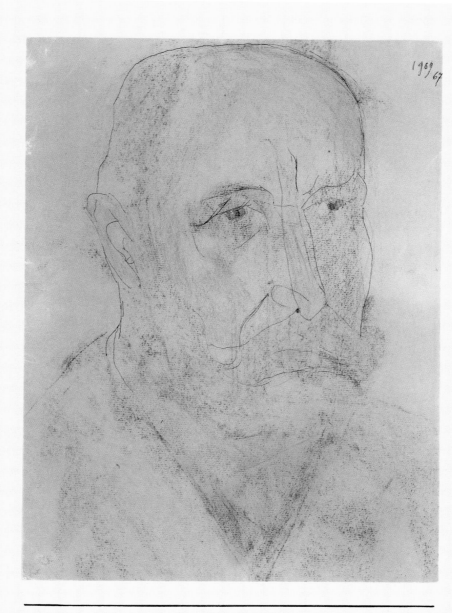

Durchgeistigung durch Primitivität

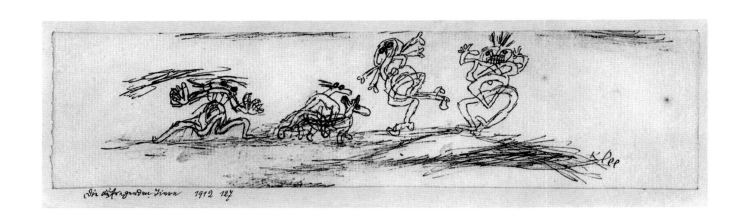

12. *Die aufregenden Tiere*
(The Agitating Animals)
1912, 127
pen and ink on paper mounted
on board
2 1/2 x 9 1/2 in. (6.5 x 24.1 cm)

13. *Zerstörung und Hoffnung*
(Destruction and Hope)
1916, 55
lithograph with watercolor
and graphite
15 7/8 x 13 in. (40.5 x 33 cm)

14. *Initiale*
(Initial)
1917, 11
Inscribed «S Kl»
watercolor, pen and ink, and
graphite on paper mounted
on board
8 3/4 x 4 1/2 in. (22 x 11. 5 cm)

14.a *Untitled*
(verso of cat. no. 14)
ca. 1917
pen and ink on paper

14 Will Grohmann notes Klee's
shift to oil painting in 1919: «As
though to disprove the criticism
that he was no more than a minia-
turist, he produced the well-known
Villa R, now in the Kunstmuseum
in Basel, *Composition with a B,
Picture with Cock and Grenadier*,
and *Landscape with Rocks*.» *Klee*,
62.
15 *Diaries*, 297, entry 926 o.
16 For the meaning of *Sonder-
klasse*, also spelled *Sonderclasse*,
within Klee's *œuvre*, see Glaese-
mer, *Klee, 9*.
17 The verso is neither signed nor
dated; however, a *circa* date has
been assigned based on the date
of the recto. *Initiale* frames the
image of the untitled work, which
shows through the sheet, indicat-
ing that the untitled work was
made first. Furthermore, it is high-
ly unlikely that Klee would have
jeopardized the integrity of *Initiale*,
which he clearly valued highly, by
adding a work on its reverse.

As an artist who favored the small format throughout his working career, Klee was often considered a miniaturist, a reputation that took hold during his lifetime and has endured posthumously.[14] While it is true that his *œuvre* comprises works that are of relatively modest proportions, the pieces he considered miniatures are but one very specific aspect of his production. Klee produced a cluster of such works during his military service in Gersthofen in 1917–18, among them *Initiale*.

A microcosmic composition of organic imagery appears in support of the single largest element of this watercolor, the green letter *I*. Bracketed by the top and left edges of the sheet are a moon and an eye amid less fully articulated shapes sugges-tive of reptilian, avian, and vegetal forms, all rendered in delicate pastel shades of blue, green, orange, and violet—a palette that reflects the influence of Klee's visit to Tunisia in the spring of 1914. «Color possesses me,» he wrote in his diaries. «I don't have to pursue it. It will possess me always. I know it. That is the meaning of this happy hour: Color and I are one. I am a painter.»[15]

The combination of visual and linguistic information in *Initiale* draws on the tra-dition of decorated letters that opened paragraphs or chapters in medieval illuminated manuscripts and, more immediately, on the practice by Klee's cubist contemporaries of using letters both to accentuate the flatness of the picture plane and to direct the viewer to multiple levels of reality within a given work of art.

Initiale was clearly a very satisfying work for Klee. On the mount below the sheet, he inscribed the letters *S Kl*, denoting *Sonderklasse*, or «special class.»[16] This rarely applied designation indicates a mark of high achievement and attests to the elevated significance of the work for the artist.

Barely visible in the central portion of the sheet is evidence that another work was drawn on the verso.[17] This untitled pen-and-ink drawing shares some imagery with the watercolor; scrolls and circles mimic portions of the *I*, and a second moon is visible as well. The work is geometrically, rather than organically, structured, however, as all of the shapes and lines seem tethered to a flat, cubist armature. JB

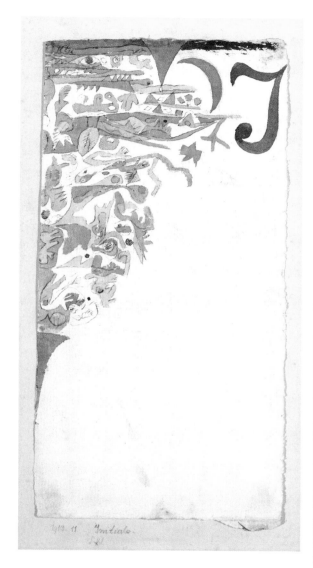

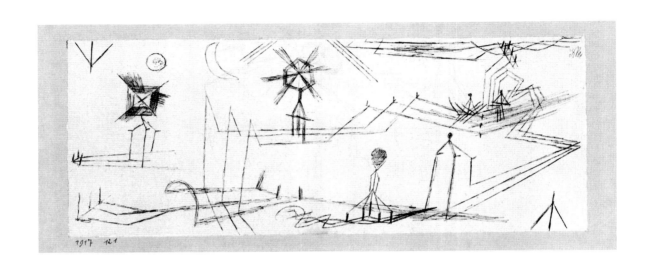

15. *Kanal Landschaft*
(Canal Landscape)
1917, 121
pen and ink on paper mounted
on board
3 3/4 x 9 5/8 in. (9.4 x 24.4 cm)

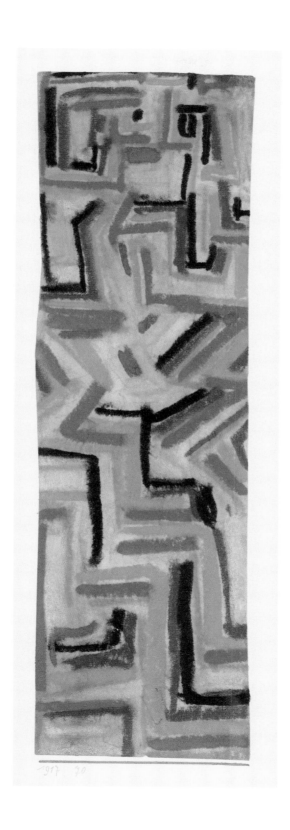

16. *Teppich*
(Carpet)
1917, 70
pastel, wet-in-wet, and watercolor
on Japan paper mounted on board
10 5/8 x 4 in. (27 x 10 cm)

17. *Vogelkomödie*
(Bird Comedy)
ca. 1918
lithograph
16 3/4 x 8 1/2 in. (42.5 x 21.5 cm)

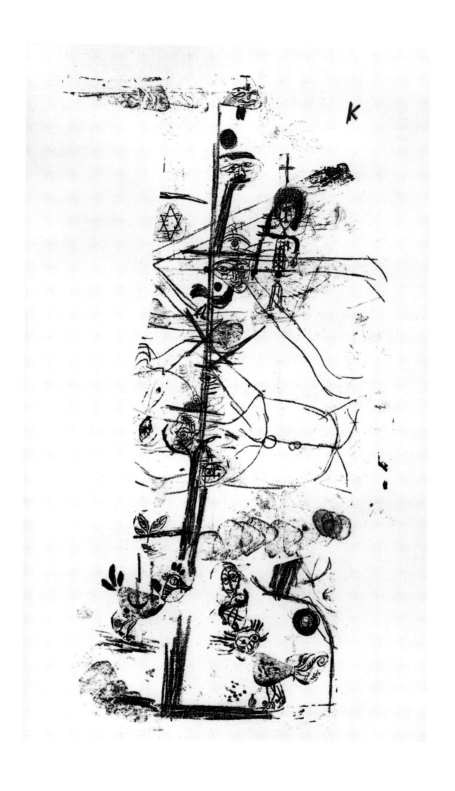

K

18. *Fata Morgana zur See*
(Fata Morgana on the Sea)
1918, 12
watercolor and pen and ink on
paper mounted on board
5 x 5 7/8 in. (12.7 x 14.9 cm)

18 Grohmann, *Klee*, 59.
19 *Ibid.*
20 Andrew Kagan, in *Guggen-heim*, 35.
21 Jim M. Jordan, *Paul Klee and Cubism* (Princeton, N.J.: Princeton University Press, 1983), 169.
22 *Diaries*, 374, entry 1081. For further discussion of the influence of optical illusions on Klee's art, see Hans M. Wingler, *The Bauhaus: Weimar, Dessau, Berlin, Chicago*, trans. Wolfgang Jabs and Basil Gilbert (Cambridge, Mass.: MIT Press, 1969), 159–60.
23 Franciscono, *Klee*, 210–11. Examples of earlier works are *Dämon über den Schiffen* (Demons over Ships), 1917, Collection of the Museum of Modern Art, New York, and *Unstern der Schiffe* (Evil Star of Ships), 1919, Collection of the Paul Klee-Stiftung, Kunstmuseum Bern.

A week after his friend and colleague Franz Marc died in battle on March 4, 1916, the German infantry reserves conscripted Klee. By January 1917 Klee was serving as a clerk at the flying school in Gersthofen, a position he held until his discharge at the end of 1918. Despite the general environment of misery and misfortune occasioned by the war, his job in the accounting office allowed Klee the time to produce far more watercolors and oil paintings than before.[18]

Fata Morgana zur See was a product of a year when color vigorously reappeared as a consistent element in Klee's art after it «had somewhat exhausted itself.»[19] Color, which he knowingly mastered during a trip to Tunisia in 1914, finally complemented a distinct linear element, devoid of its earlier agitated, nervous energy. The thin lines clearly determine the pictorial structure and serve as boundaries for the thin, translucent color washes.[20] Outlined are areas of pink, violet, and sea green, palette additions Klee adopted after seeing the work of Marc Chagall in Berlin in January 1917.[21]

Throughout his career, Klee worked—sometimes concurrently—in both abstract and representational modes. This sheet combines the two styles, for distinct masts, flags, and a smokestack of a ship appear in the lower right corner while a dominant arrangement of fractured shapes floats above. Given Klee's musical training, the shapes alternately suggest a rhythmic design of violin soundboards and scrolls, fermatas, bass clefs, and notes. Either interpretation of the subject matter adapts to a structure informed by earlier experiments with synthetic cubism and by Robert Delaunay's color theories.

A *fata morgana* is a complex optical illusion in which images of objects such as ships and houses appear suspended in the air over the object itself or over water. Akin to the refraction of visible light into a spectrum of colors, the mirage separates into billowing sails and related components which ascend gracefully. Such scientific wonders challenged Klee. He wrote in a diary entry: «The diffused clarity of slightly overcast weather is richer in phenomena than a sunny day. … It is difficult to catch and represent this, because the moment is so fleeting. It has to penetrate into our soul.»[22] Though much of Klee's work dealing with nautical themes from 1916 and 1917 was «informed by his reaction to and thoughts on World War I» and offered an evil or moral content, *Fata Morgana* presents a delightful, childlike creation.[23] KP

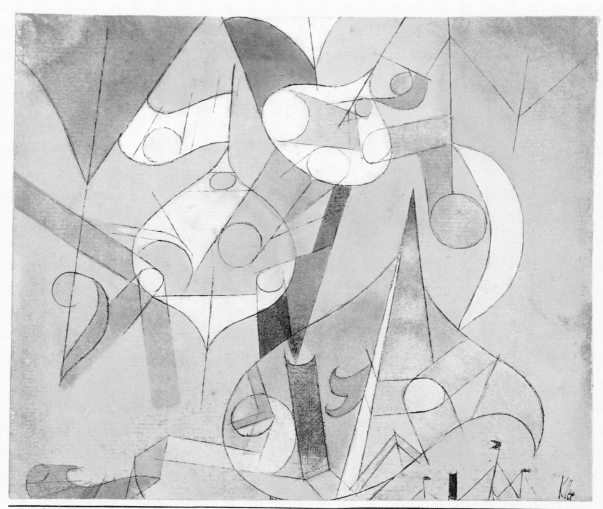

1918 . 12 . Fata morgana Zur See

19. *Versunkenheit*
(Absorption)
1919, 75
graphite on paper mounted
on board
10 5/8 x 7 5/8 in. (27 x 19.5 cm)

59

20. *Insecten (Schöpfungsplan 24)*
(Insects [Plan of Creation 24])
1919, 114
lithograph with watercolor stencil
8 x 5 5/8 in. (20.6 x 14.5 cm)

21. *Bildnis eines Knaben*
(Portrait of a Boy)
1919, 91
oil transfer drawing on paper
mounted on board
9 3/8 x 7 3/8 in. (24.1 x 19.1 cm)

22. *Ein Genius serviert ein kleines Frühstück, Engel bringt das Gewünschte*
(A Spirit Serves a Small Breakfast, Angel Brings the Desired)
1920, 91
lithograph with watercolor
8 x 5 3/4 in. (20.3 x 14.5 cm)

22.a *Ein Genius serviert ein kleines Frühstück, Engel bringt das Gewünschte*
(A Spirit Serves a Small Breakfast, Angel Brings the Desired)
lithograph
8 x 5 3/4 in. (20.3 x 14.5 cm)

24 Gert Schiff, «Klee's Array of Angels,» *Artforum* 25 (May 1987): 126.
25 The 1915 drawing is reproduced in Lanchner, *Klee*, 161.
26 See, for instance, the 1921 lithograph *Herz-Dame* (Queen of Hearts), cat. no. 26.

One of Klee's central motifs was the angel. Appearing in many different forms in his work—merciful, kind, sad, all-knowing—these winged creatures function as a bridge between the realms of the spirit and the earth, existing solely in neither one nor the other, but in a place in-between.

The two versions of this lithograph reveal a serious, albeit whimsically rendered angel who dutifully brings a breakfast tray to an unknown recipient. Her overlarge eye intent on the task, this celestial creature strides with the brisk, almost mechanical gait of a wind-up toy. The very thin lines that articulate the angel's form simultaneously reveal her internal and external structure and tether her to a flat, vaguely cubist armature that bisects the double-arched composition. It has been suggested that her headgear resembles a nurse's cap,[24] a notion that is strengthened by the red watercolor additions in the hand-colored version (cat. no. 22) that lend the print the colors of the Red Cross.

Most of the prints that Klee made in the teens and early twenties were prompted by invitations he received to contribute to group portfolios: the uncolored lithographic version of this work (cat. no. 22a) appeared in *Die Freude: Blätter einer neuen Gesinnung*, edited by Wilhelm Uhde and published in an edition of fifty. It was highly unusual for Klee to develop compositions directly onto an etching plate or lithographic stone. More typically, he would make preparatory drawings or mine the resources of his earlier production for inspiration, in this case a pen-and-ink drawing of the same design from 1915.[25] The Djerassi collection includes both an uncolored and a colored version, to which Klee added a pale pink wash over the central portion of the print and strokes of more concentrated pigment to enframe it. The most significant addition is the symbol of the heart, which mimics, in shape, the double-arched format. As a favored device of the early 1920s,[26] the genie's new heart is less suggestive of her circulatory system than of her benevolent spirit. In this angel's hands, one would appear to be in the right care. JB

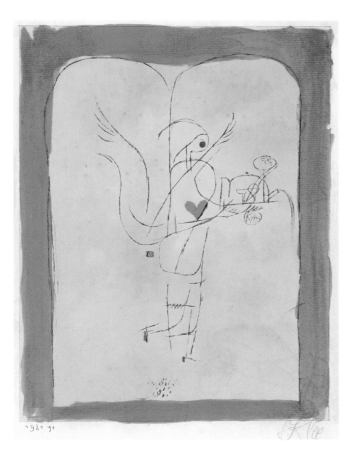

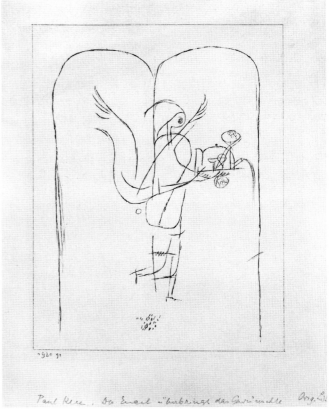

23. *Barockbildnis (Herr zu Perrücke)*
(Baroque Portrait [Lord Wig])
1920, 9
watercolor on paper mounted
on board
10 x 7 1/8 in. (25.5 x 18 cm)

Only on rare occasions did Klee's interest in human physiognomy manifest itself in anything close to traditional portraiture, which customarily features a known subject and some degree of physical likeness to the individual. Though this drawing is outwardly a generalized visage, Klee's entry for it in his *œuvre* catalogue actually indicates a «sitter» for the stylized, sexually and racially ambiguous subject—a certain Herr zu Perrücke.[27] Translated into English, the gentleman's name becomes «Lord Wig» or «Lord Peruke,» the latter referring to a specific type of European wig popular from the seventeenth to the early nineteenth century. True to Klee's penchant for *double entendres*, the surname is a pun on the figure's wild, predominantly blue and white hair. Reinforcing the sense of a removable hairpiece, the effusive curly locks hover above the heart-shaped face as if resting on a different plane, far closer to the surface of the paper.

Titled as a portrait, the work strikingly resembles an acknowledged self-portrait of the previous year (cat. no. 19), raising the possibility that the artist used himself as the subject. Klee additionally felt a special kinship with actors, often defined as creators of multiple personae. The red-colored lips, darkly penciled eyebrows, shaded eyelids, and rouged cheeks suggest the heavy application of theatrical makeup or the presence of a mask. The notion of masquerade further offers an explanation for the unnaturalistic color selections. Such an assumption of disguise would befit the whimsical Klee and promote him to the rank of his favorite baroque composers, such as Handel, Scarlatti, and Bach. Alternatively, the solemn expression and Greek cross or possibly *pommée* dangling around the neck of the individual convey a reverential mood, symbolic perhaps, of the artist's deep attachment to the world of music.

In the lower right, superimposed on the figure's shoulder, Klee has signed the work with a delicately drawn scroll from a violin, his lifelong musical instrument of choice. Placed as if on a stamp or wax seal, this musical element becomes a referent, cleverly assuming the conventional placement and role of a signature. The scroll further appears to extend across the bottom of the image via orange lines, outlining a ribbon or band, which would characteristically bear a name or inscription in certain sixteenth-century styles of portraiture. JB/KP

27 Letters from Hugo Wagner, Director, Paul Klee-Stiftung, Kunstmuseum Bern, to Dr. Carl Djerassi, 1 December 1971 and 25 August 1972.

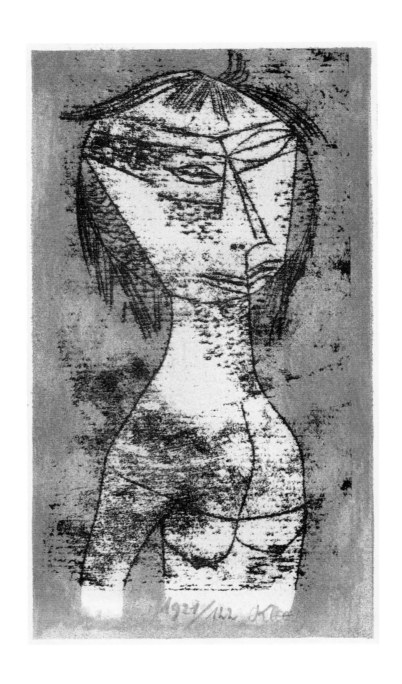

24. *Die Heilige vom innern Licht*
(The Saint of Inner Light)
1921, 158
graphite on paper
12 1/2 x 8 7/8 in. (31.7 x 22.5 cm)

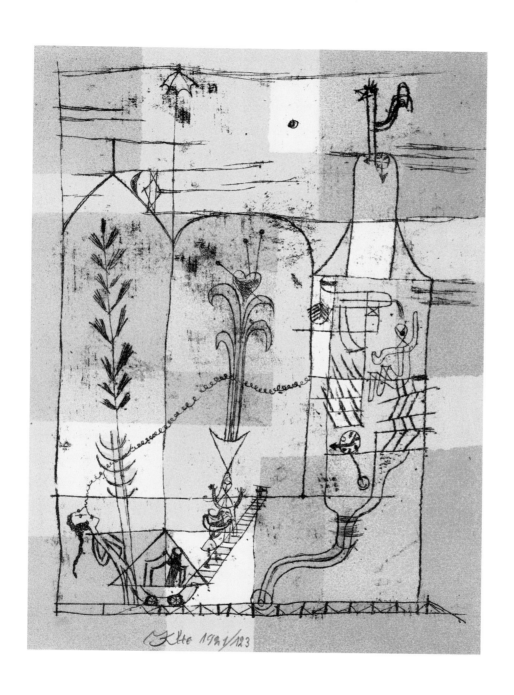

25. *Hoffmanneske Märchenscene*
(Hoffmannesque Fairy Tale Scene)
1921, 123
color lithograph
12 1/2 x 9 in. (31.6 x 22.9 cm)

26. *Herz-Dame*
(Queen of Hearts)
1921, 30
lithograph
10 x 6 7/8 in. (25.5 x 17.6 cm)

27. *Die Knospe des Lächelns*
(The Budding Smile)
1921, 159
graphite on paper mounted
on board
11 x 6 1/2 in. (28 x 16.5 cm)

28. *Laternenfest Bauhaus 1922*
(Bauhaus Lantern Festival 1922)
1922
lithograph with watercolor
3 1/2 x 5 5/8 in. (8.9 x 14.4 cm)

29. *Die Hexe mit dem Kamm*
(The Witch with the Comb)
1922, 101
lithograph
12 1/4 x 8 3/8 in. (31 x 21.2 cm)

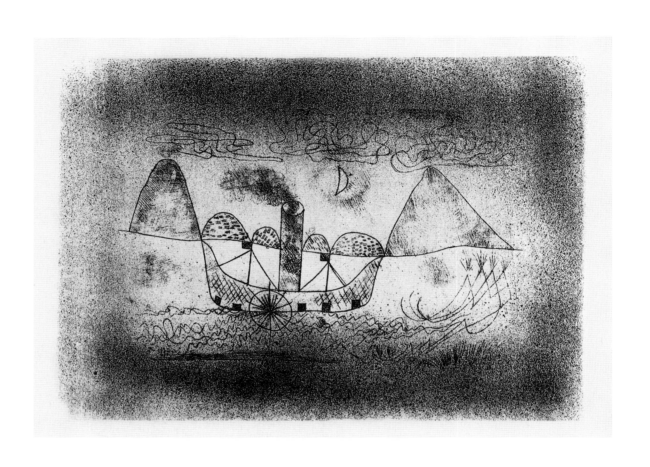

30. *«Lugano»*
(«Lugano»)
1922, 67
lithograph
11 x 15 1/4 in. (27.8 x 38.8 cm)

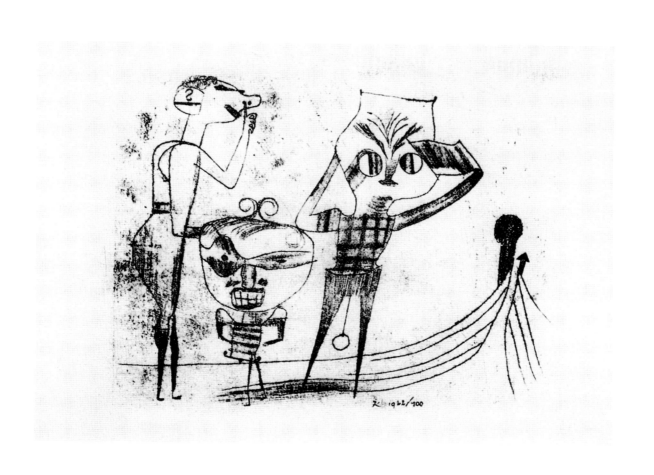

31. *Vulgaere Komoedie*
(Vulgar Comedy)
1922, 100
lithograph
8 1/2 x 10 3/4 in. (21.5 x 27.3 cm)

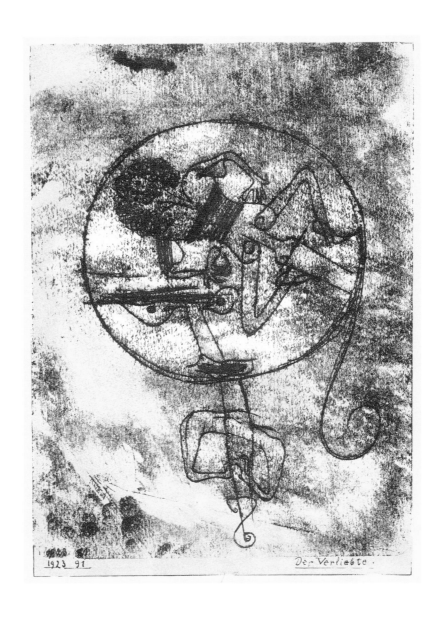

32. *Der Verliebte*
(Man in Love)
1923, 91
color lithograph
10 3/4 x 7 1/2 in. (27.4 x 19 cm)

33. *Nord see insel*
(North Sea Island)
1923, 180
watercolor on paper mounted
to paper with gouache, mounted
on board
14 1/2 x 20 1/2 in. (37.1 x 51.8 cm)

34. *Postkarte zur Bauhaus Aus-stellung «die erhabene Seite» 1923*
(Postcard for the Bauhaus exhibition «The Sublime Aspect» 1923)
1923, 47
color lithograph
5 5/8 x 3 in. (14.3 x 7.5 cm)

A pictorial work ... is constructed bit by bit, just like a house.[28]

Three small-scale lithographs in the Djerassi collection—*Laternenfest Bauhaus 1922* (cat. no. 28), *Die heitere Seite* (cat. no. 36), and *Die erhabene Seite*—had their genesis in the publicity of early Bauhaus events. The former announced a summer solstice celebration of 1922, while the latter two were printed for the most significant event of the Weimar Bauhaus: the grand summer exhibition of 1923. From 15 August to 30 September the members of the Bauhaus revealed to the public for the first time their innovative artistic and architectural theories in a multimedia show accompanied by performances of music by Hindemith and Stravinsky and the premiere of Schlemmer's *Triadic Ballet.*

Prior to the exhibition, Bauhaus masters and apprentices created postcard advertisements, twenty of which were selected for printing, including works by Lyonel Feininger, Vassily Kandinsky, László Moholy-Nagy, and two by Klee. While the other work Klee designed—*Die heitere Seite* (The Bright Aspect, cat. no. 36)—alludes to Bauhaus parties, *Die erhabene Seite* captures the central Bauhaus interest in architectural structure. For this piece, Klee reworked the ink drawing *Inschrift* (Inscription) of 1918, which he had made during his military service as a clerk in the paymaster's office of the flying school in Gersthofen.[29] With carefully stacked elementary geometric forms that create a soaring tower, *Inschrift* proved to be an apt model for a postcard that would perfectly illustrate the cardinal tenet of the Bauhaus's founder, Walter Gropius: «The ultimate aim of all visual arts is the complete building!»[30] In the lithograph, a separate color—red, blue, yellow, or white—fills each black-delineated circle, square, or triangle, as though they were individual sections in stained-glass windows. Klee not only added color but solidified the structure of the tower and adjusted the text of the original drawing, replacing his stray number tallies and reference to Gersthofen with text at both the bottom and top of the composition announcing the show. Like lashes, the words *Weimar/Bauhaus Austellung 1923* frame the all-seeing single eye that crowns the double-doored edifice, the entrance to the Bauhaus that assumes an elevated position, closer to the «sublime.» JB

28 Klee, «Creative Credo,» 184.
29 *Inschrift* is reproduced in Lanchner, *Klee,* 146, and *Graphic Legacy,* 110.
30 Walter Gropius, «Program of the Staatliche Bauhaus in Weimar,» in Hans M. Wingler, *The Bauhaus: Weimar, Dessau, Berlin, Chicago,* trans. Wolfgang Jabs and Basil Gilbert (Cambridge, Mass.: MIT Press, 1964), 31.

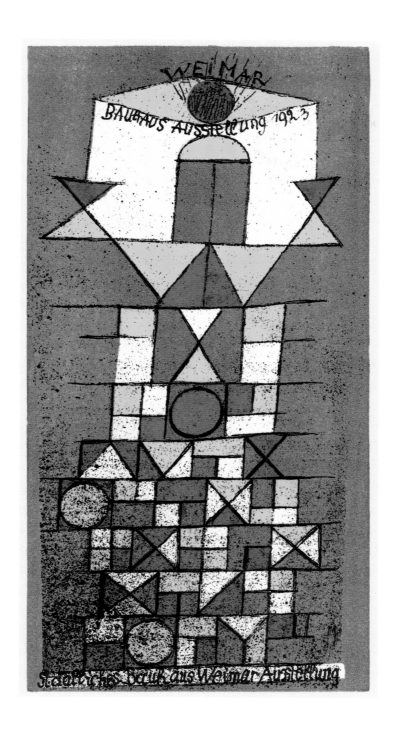

35. *Baltrum (gegen Langeook)*
(Baltrum [toward Langeook])
1923, 264
graphite on paper mounted
on board
5 1/4 x 11 3/4 in. (13.4 x 30 cm)

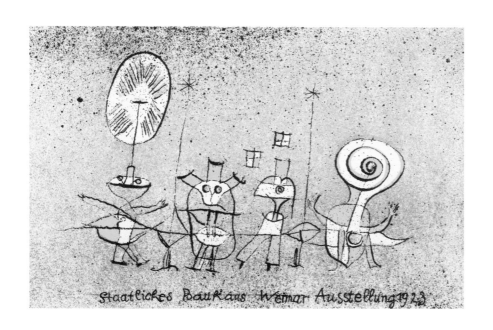

Staatliches Bauhaus Weimar Ausstellung 1923

36. *Postkarte zur Bauhaus Aus-*
stellung «die heitere Seite» 1923
(Postcard for the Bauhaus Exhibition
«The Bright Aspect» 1923)
1923, 48
color lithograph
3 7/8 x 5 5/8 in. (9.9 x 14.4 cm)

37. *Mazzaró*
(Mazzaró)
1924, 218
gouache and watercolor on paper
mounted on board
9 1/8 x 12 in. (23.3 x 30.6 cm)

31 Grohmann, *Klee*, 71.
32 The Villa Mazzaró could have
been the residence of an Alberto
Pagni, as Grohmann cites the title
of this work as *Mazzaró (Alberto
Pagni)*. See *ibid.*, 414.
33 Andrew Kagan, «Klee's
Development,» in *Guggenheim*,
29.
34 The related works (all from
1924) known to the author are
Bei Taormina (Scirocco) (Near
Taormina [Scirocco]), *Bei Taormina
(heiter)* (Near Taormina [Bright]),
Strasse bei Villa Mazzaró (Street
near Villa Mazzaró), illustrated
in Glaesemer, *Klee*, 164, 223;
and *Villa Mazzaró*, illustrated in
Sotheby's, New York, 15 November
1984, lot 138.
35 Klee, *Briefe*, vol. 2, 995 in
Sabine Rewald, *Paul Klee: The
Berggruen Klee Collection in The
Metropolitan Museum of Art*,
exh. cat. (New York: The Metro-
politan Museum of Art, 1988), 200.
36 Klee, *Briefe*, vol. 2, 997, in
Rewald, *Paul Klee*, 200.

While on summer break from teaching at the Bauhaus in 1924, Klee vacationed for six weeks on Italy's largest island, Sicily, traveling to Taormina, Mazzaró, Syracuse, and Gela. The largely mountainous and sun-drenched landscape of the Mediterranean isle deeply affected the artist. In response to the «pure landscape in the abstract,» he created a body of work that effectively records the topography, color, and atmosphere particular to a unique geographic location.[31] From the clay-tile roof and bleached white walls of the country house to the vegetation and ceramic urns, *Mazzaró* depicts a recognizable locale with a rose-hued mountain peak rising in the distance to the right.[32]

In technique, *Mazzaró* retains vestiges of Klee's cubist efforts and relates to his «magic square» series begun in 1923. Each pictorial element is treated as a separate part—as a relatively flat, unmodeled shape—all layered together as if a collage. Possibly owing to his former position as *Formmeister* in the stained-glass workshop at the Bauhaus, Klee further imparts a stained-glass quality by utilizing a procedure employed in old-master works. This involved applying semi-opaque and more transparent coats over a dark underpainting.[33] In *Mazzaró*, the artist carefully applies the paints in contained shapes, allowing an outline of black to remain around each area of color. The result is a texturally rich, velvety composition, which glows from a light source seemingly located deep beneath the strata of pigment.

When viewed as a whole, the Sicilian works serve as studies documenting the effects of variable light, caused by changing weather conditions or times of day.[34] Given the darkened skies and suffused light, *Mazzaró* captures a moment nearing dusk. In contrast, a closely related work, *Villa Mazzaró*, offers nearly the same view rendered with sketchy, open brushwork in pastel colors, allowing much of the white paper to be seen. This loose application of the gouache creates a milieu awash with the brightness offered only by the sun only at the height of day. In the kindred paintings, color, light, and a sense of place equally become the subject matter.

During the fall at the Bauhaus long after the summer travels were over, Klee wrote to his wife, Lily, about the impending move of the school, «Here everyone is in feverish activity in anticipation of the great crisis about to happen. ... I am still so filled with Sicily that it hardly touches me.»[35] To Klee, a man of introspective mien and tepid political tendencies, the memories of Sicily continued to infuse his thought and work—«I experience nothing, don't even want to. I carry the mountains and the sun of Sicily with me. Everything else is boring.[36]

KP

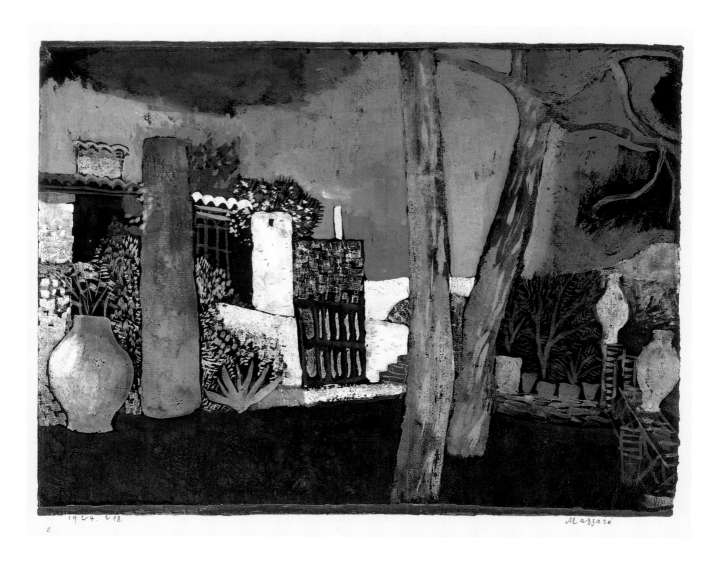

1924. 218. Mazzaro

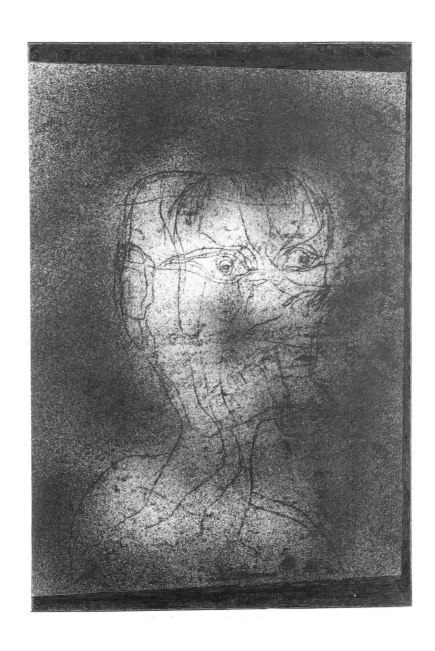

38. *Alter Mann*
(Old Man)
1924, 255
oil-transfer and watercolor, sprayed,
on paper, with watercolor and pen
and ink strips top, bottom, and right,
mounted on board
14 1/8 x 9 1/2 in. (36 x 24 cm)

39. *Oriental. Mädchen*
(Oriental Girl)
1924, 256
oil-transfer and watercolor, sprayed,
on paper mounted on board
11 3/4 x 9 1/8 in. (29.8 x 23.2 cm)

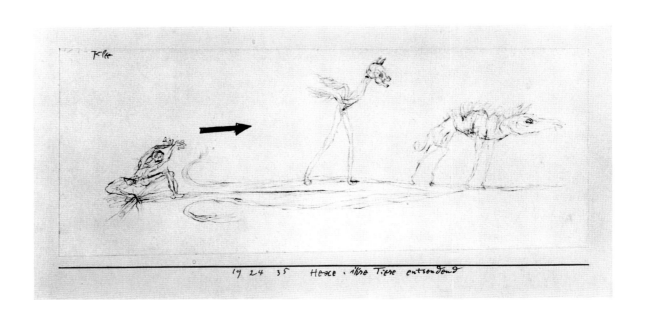

40. *Hexe, ihre Tiere entsendend*
(Witch, Dispatching Her Animals)
1924, 35
pen and ink on paper mounted
on board
4 x 9 3/8 in. (10.2 x 23.8 cm)

41. *KRAPP Mein Hund*
(KRAPP My Dog)
1924, 89
pen and ink on paper mounted
on board
11 3/8 x 8 1/2 in. (29 x 21.6 cm)

42. *Kleine Winterlandschaft mit dem Skiläufer*
(Small Winter Landscape with Skier)
1924, 85
Inscribed «S Cl»
watercolor on paper mounted
on board
6 x 8 3/4 in. (15.2 x 22.3 cm)

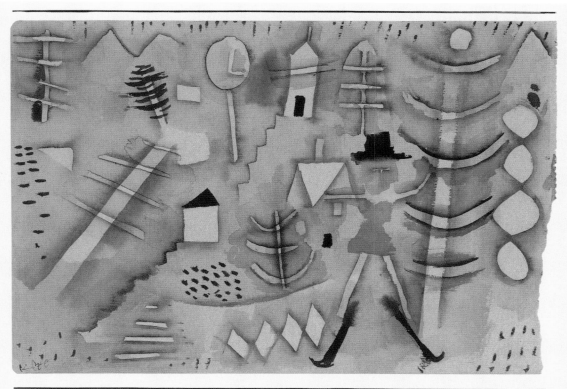

1924. 85. kleine Winterlandschaft mit dem Skitourist

43. *Pferd und Mañ*
(Horse and Man)
1925, 105 (A5)
oil-transfer, pen and ink, and water-
color, part sprayed, on paper,
mounted on board with watercolor
and pen and ink
13 3/8 x 19 3/4 in. (34 x 50.2 cm)

37 Mark Rosenthal, «Paul Klee
and the Arrow» (Ph.D. diss., Uni-
versity of Iowa, 1979), 146.
38 In *ibid.*, 74. The motif of the
arrow is seen regularly from Klee's
juvenilia to his last works. The
artist also made the arrow a full
lecture topic for students at the
Bauhaus.

Pferd und Mañ presents a variant of a horse-and-rider theme in which the man, rather than riding atop the animal, strides side by side with the horse toward the right of the picture. The human and the animal—both drawn with a whimsical, almost cartoonlike line—bear remarkably similar features, an example of how Klee unhierarchically equated the world of animals with that of human beings.

It has been suggested that in *Pferd und Mañ*, the bright red arrow that hovers above the figures predicts the two travelers' fate, functioning like a gently prodding finger[37] and encouraging them on their illuminating journey. Somewhat disjunctive in the context of a representational (if not particularly objective) composition, the arrow seems to have redirected the man, whose face can also be made out in the murky darkness to the left (much larger and facing the opposite direction). Klee has given pictorial form to a higher force that is felt but not seen. The arrow is clearly on the sheet but seems to indicate an invisible force. «The father of the arrow is the thought,»[38] Klee wrote in his theoretical textbook, *Pädagogisches Skizzenbuch* (Pedagogical sketchbook), and in this image the arrow indeed seems to have provided supplementary mental powers to the man and the horse. Klee's use of the arrow is one of the most striking examples of the personal nature of his symbolism. An abstract sign—which through established cultural convention is interpreted as directional—takes on a host of other meanings within Klee's system, the language of form that he developed in his pictures. Klee was also keen on wordplay and adapted written language to suit. Beneath the figures, the artist has penned the title of the watercolor, dropping an *n* from the spelling of *Mann* and adding a straight line over the remaining *n*, borrowing a symbol from mathematics to indicate an infinitely repeating value. Perhaps the journey of the horse and the man is not meant to have a final destination. JB

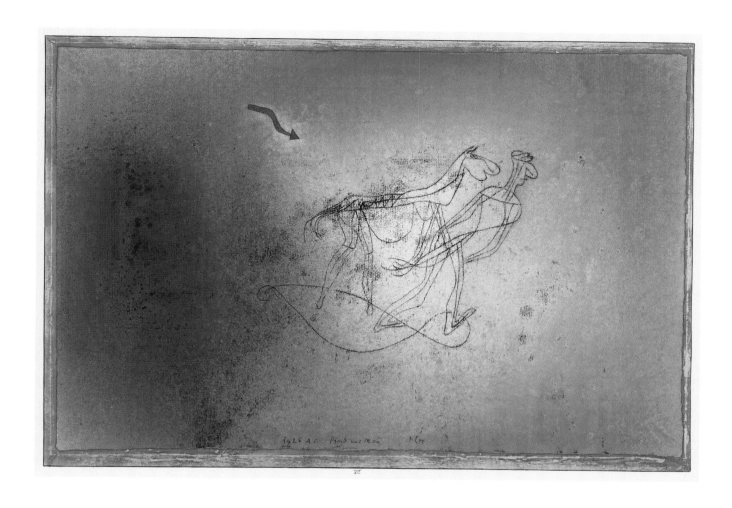

44. *Figurine mit Kopfputz*
(Figurine with Headdress)
1925, 178 (H 8)
pen and ink and graphite on paper
mounted on board
10 3/4 x 5 in. (27.6 x 12.6 cm)

45. *Geburtstags Kind*
(Birthday Child)
1925, 125 (C3)
pen and ink on paper mounted
on board
4 3/8 x 4 in. (11 x 10.1 cm)

1925, 147: ein Dampfer im Hafen

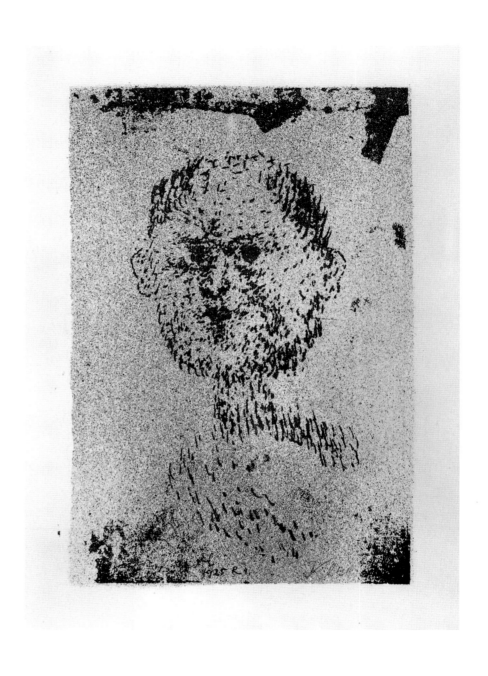

47. *Kopf*
(Head)
1925, 84 (R4)
watercolor, sprayed, on lithograph
8 5/8 x 6 in. (22 x 15.4 cm)

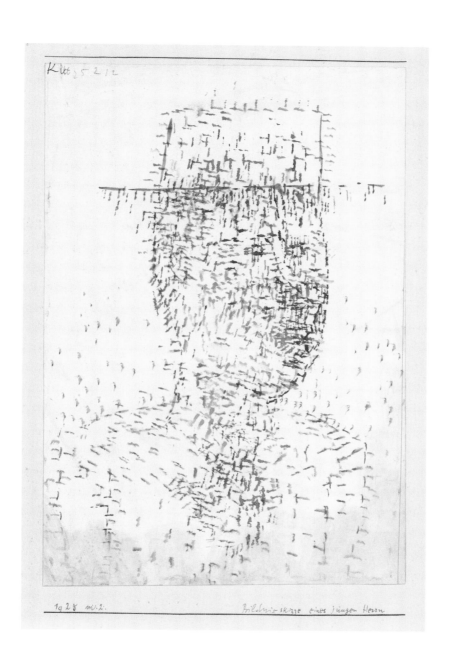

48. *Bildnisskizze eines jungen Herrn*
(Portrait Sketch of a Young Man)
1925, 32 (M 2)
watercolor on ground on paper
mounted on board
7 1/2 x 5 in. (19 x 12.7 cm)

49. *Wald bei G.*
(Forest near G.)
1925, 139 (D 9)
watercolor, and pen and ink on
paper mounted on board
5 3/8 x 12 3/4 in. (13.7 x 32.4 cm)

50. *Das Sumpfbein*
(The Swamp-Leg)
1926, 9
pen and ink and graphite on paper
mounted on board
7 5/8 x 12 5/8 in. (19.3 x 32 cm)

Despite the presence of a conspicuous figure, the true meaning of *Heldenmutter* is elusive, obfuscated by ambiguity and complexity, two themes frequently at the heart of Klee's work. Uncertainty first arises with the title, interpreted as either «Mother of Heroes» or «Hero Mother.» On the one hand, given the precipitous rise in power of the National Socialist German Workers', or Nazi, party in Germany coupled with the lingering remembrances of World War I, the artist possibly illustrates a position shared by many women, one filled with anguish and fear for their sons' fate in the world. On the other hand, the subject may be a depiction of, or even a tribute to, the innately powerful role embodied by a mother. The crux, however, rests in the determination of gender. Though the title indicates a female identity, the large hands and feet and the lack of any discernible feminine attributes raise the possibility that the figure is male. Amplifying the androgynous quality, a careful inspection of the person's garments, perhaps a robe and tights, reveals folds in the cloth that suggest underlying male genitalia.

Perhaps the explanation for such intriguing contradictions lies in Klee's fondness for ancient cultures; the «idea of antiquity … was latent in him.»[39] By 1927 his journeys had included a year-long sojourn in Italy and a trip there twenty-five years later, allowing much exposure to the architectural remains of cultures past. Klee simultaneously developed a predilection for Greek and Roman literature dating from antiquity, particularly the tragedies of Aeschylus and Sophocles.[40] When likened to an individual delivering a soliloquy while isolated on a proscenium, *Heldenmutter* presents a male actor playing the role of a female character. Here, the character assumes a secondary role to the protagonist; she is captured at the moment where the hero meets his demise.

Klee combined several techniques that masterfully achieve an unnerving sense of doom. Repetitive curved lines, a derivative of the parallel line-work style developed and refined by the artist from 1925 to 1934, generate a nervous, agitated rhythm. Propelled as if by centrifugal force, the arms, hands, and feet seem positioned to press the edges of the image outward. Klee may have sprayed pigment from an atomizer, a tool he began using in 1924. Repeated applications of the same or different shades would account for the unevenness and mottling while the masking of certain areas would produce lighter patches. Encircling the intensely illuminated head and upper body, a swirling mass of nebulous vapors shroud the figure—the ill winds boding adversity and disaster.

KP

39 Grohmann, *Klee*, 265. Other works of art from this period exhibit an antique flavor. See, for example, *Ein Garten für Orpheus* (A Garden for Orpheus), 1926, *Ein Vorspiel zu Golgatha* (A Prelude to Golgatha), 1926, and *Ansicht eines Bergheiligtums* (View of a Mountain Sanctuary), 1926, pp. 368, 398, and 225 respectively, in Grohmann.
40 *Ibid.*, 265

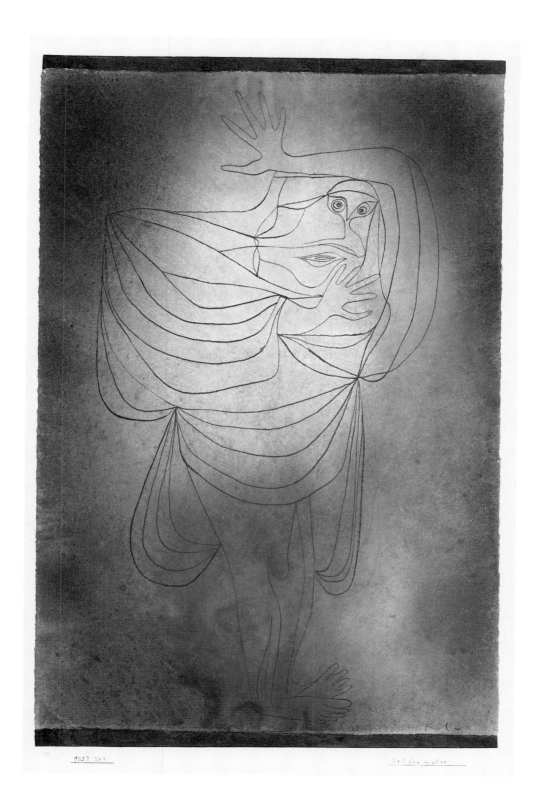

1927 24.0 Heldenmutter

52. *Pflanzlich – schlimmes*
(Vegetal – Evil)
1927, 119 (B 9)
pen and ink on paper mounted
on board
9 1/4 x 12 1/4 in. (23.5 x 31 cm)

1927 B9 pflanzlich-schlimmes

53. *Negride Schönheit (Præcision)*
(Negroid Beauty [Precision])
1927, 192 (T 2)
pen and ink and graphite on paper
mounted on board
17 1/4 x 13 in. (44 x 33 cm)

Often I said that I served Beauty by drawing her enemies (caricature, satire). But that is not enough. I must shape her directly with the full strength of my conviction. A distant, noble aim. ... I already set out on that path. ... Perhaps the road is longer than my life.[41]

Despite the initial doubt conveyed in this entry from Klee's diary from 1900, the masterful depiction of beauty would not elude him perpetually. In *Negride Schönheit (Præcision)*, the artist records, through a minimum of means, the image of a woman who embodies the accepted ideals of beauty particular to that time. Created while Klee was teaching at the Bauhaus in Dessau, this work is one of four unusually large drawings, each a portrait of a woman, collectively known as the *Precision Series*.[42] Two others additionally focus on beauty: *Semitische Schönheit* (Semitic Beauty) and *Chinesische Schönheit* (Chinese Beauty). The fourth and final piece, however, is titled *Hässlichkeit* (Ugliness), featuring a hideous woman with exaggerated, yet unmistakably Caucasian, features.

Though linked to the tradition of caricature, an art form Klee practiced from his early school days,[43] the images are more strongly descriptive and serious in nature. These studies concentrate on the arrangement and shapes of physiognomic traits— eyes, eyebrows, noses, and mouths—and coiffures. Approached from a contemporary era espousing multiculturalism, Klee's selected iconography could be interpreted as ethnically insensitive. However, when taking into account that «Klee had always tended to use drawing as a means of recording,»[44] the work is a technical exercise in representing a distinctive fashionable face «that was quite in the spirit of the times.»[45]

For *Negride Schönheit*, Klee chose a renowned visage, that of Josephine Baker (1906–1975), the American-born entertainer. After her dazzling Paris dance debut in the 1925 *Révue nègre*, European mass culture immediately embraced Baker as a paragon of modern beauty. Though unidentified in the title, Baker is easily recognized from her trademark heavily lined almond-shaped eyes and slicked-back, smooth hairstyle.

On first impression, the gentle curves, softly suggested volumes, and refined mood combined with the peculiar subject matter do not seem to have come from the hand of Klee, who favored constructivism at the time. Closer inspection reveals a geometric configuration, a distinct group of rays or diverging lines emanating from a single point in the lower left corner. Rendered in pencil, these lines, which grow fainter near the base of the woman's neck, extend diagonally to the opposite corner. The two outermost lines serve as boundaries for the head, while the resultant pattern determines the placement of specific lineaments. Similar design elements composed of rays form the corners of Baker's mouth; created by careful cross-hatchings, the isolated mouth becomes an abstract construction bearing Klee's distinct imprimatur. KP

41 *Diaries*, 49–50, entry 142.
42 Felix Klee, *Paul Klee: His Life and Work in Documents* (New York: Braziller, 1962), 195. For reproductions of the complete series, see Jürgen Glaesemer, *Paul Klee: Handzeichnungen II: 1921–1936* (Bern: Kunstmuseum Bern, 1984), 104.
43 For a discussion of caricature in Klee's work, see Franciscono, *Klee*, 18–23, 32–34.
44 *Ibid.*, 276.
45 Glaesemer, *Handzeichnungen II*, 104.

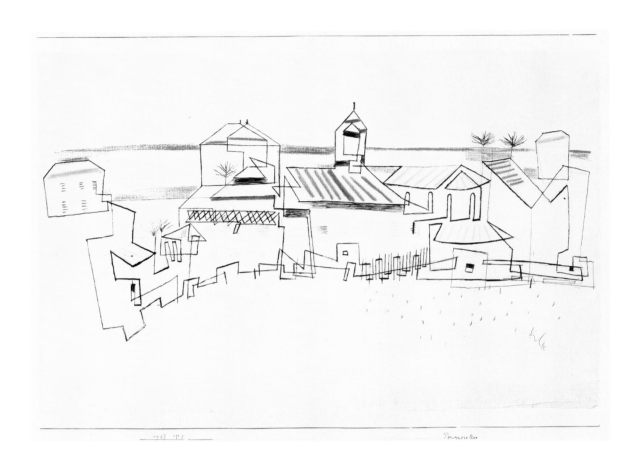

54. *Porquerolles*
(Porquerolles)
1927, 195 (T 5)
pen and ink, chalk, and graphite
on paper mounted on board
12 x 18 in. (30.5 x 45.7 cm)

55. *Weñ sie nicht mehr dran glauben*
(When They Do Not Believe It Any-
more)
1927, 259
pen and ink on paper mounted
on board
12 x 18 1/4 in. (30.5 x 46.5 cm)

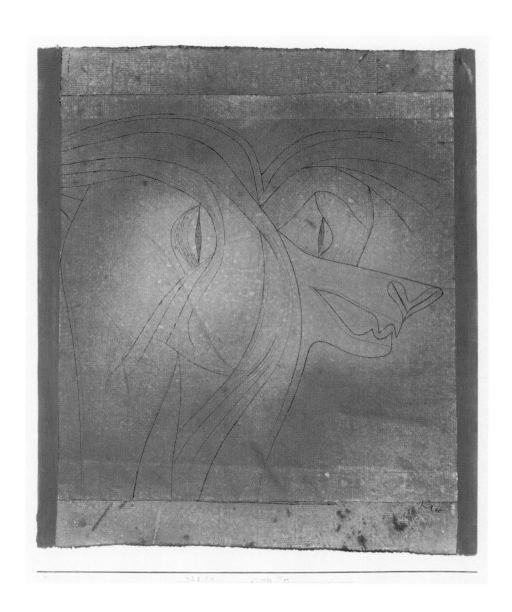

56. *Grosses Tier*
(Large Beast)
1928, 50 (N10)
watercolor, part sprayed, and pen
and ink on paper, mounted to board
with gouache
14 3/4 x 12 5/8 in. (37.5 x 32.1 cm)

57. *Aus Meinem Auge! Schnecke!*
(Out of my Eye! Snail!)
1928, 182 (J 2)
pen and ink on paper mounted
on board
13 x 8 1/4 in. (33 x 21 cm)

58. *Rotes Haus*
(Red House)
1929, 223 (W 3)
oil on canvas mounted on cardboard
10 x 10 7/8 in. (25.4 x 27.6 cm)

Formerly we used to represent things visible on earth, things we either liked to look at or would have liked to see. Today we reveal the reality that is behind visible things, thus expressing the belief that the visible world is merely an isolated case in relation to the universe and that there are many more other, latent realities. Things appear to assume a broader and more diversified meaning, often seemingly contradicting the rational experience of yesterday. There is a striving to emphasize the essential character of the accidental.[46]

Painted during the period that Klee and his friend Vassily Kandinsky were on the faculty of the Bauhaus in Dessau, *Rotes Haus* is a brilliant example of Klee's tendency to straddle a border between purely geometric forms and cartoonlike, cryptic, but recognizable imagery. Rudimentary architecture is suggested by red shapes recalling a wall, a roof, and a portal, situated in a middle ground also occupied by a geometric form that appears to represent a tree. *Rotes Haus* was painted shortly after the artist returned from a journey to Egypt, and its warm palette may reflect the deep impact the trip made on Klee. In a letter written in Egypt, Klee observed, «What is civilization, good or bad, compared with this water, this sky, this light?»[47]

Certainly, the abstract character of *Rotes Haus* and the intense, nearly monochromatic color create an impression that evades easy description, and the natural phenomena that so impressed Klee in Egypt may account for the elemental quality of *Rotes Haus*. As Klee's most famous dictum says, «Art does not reproduce the visible; rather it makes visible.»[48] In this spirit it is unnecessary to seek a precise interpretation of *Rotes Haus*. Essential are its overall sense of organization and the intuitive, mysterious nature of the scene unfolding within Klee's intimate landscape. JSW

46 Klee, «Creative Credo,» 182.
47 Paul Klee, as quoted in Donna Graves, *Pattern and Process: Nature and Architecture in the Work of Paul Klee*, exh. cat. (San Francisco: San Francisco Museum of Modern Art, 1987), 19.
48 Klee, «Creative Credo,» 182.

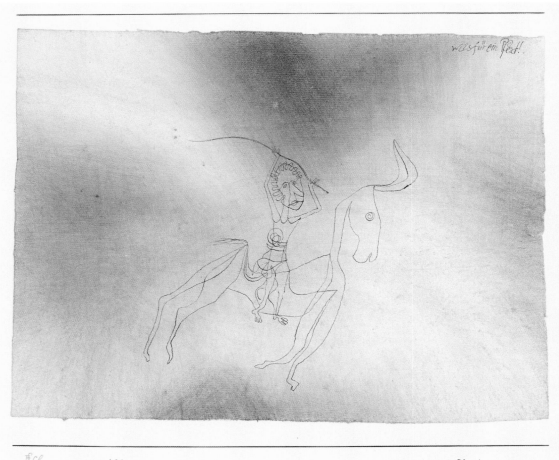

59. *Was für ein Pferd!*
(What a Horse!)
1929, 264 (AE 4)
Inscribed «S Cl»
pen and ink and watercolor on
paper mounted on board
9 1/4 x 12 1/4 in. (23.4 x 31 cm)

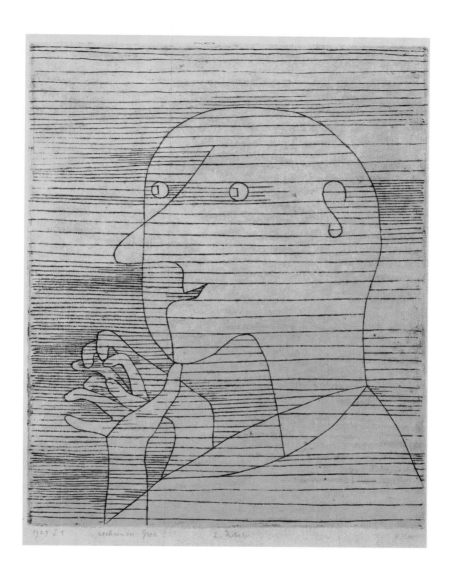

60. *Rechnender Greis*
(Old Man, Reckoning)
1929, 99 (S 9)
etching, A.P., 125
11 3/4 x 9 3/8 in. (29.9 x 23.9 cm)

61. *Überbeschwingte I*
(The Over-elated Ones I)
1930, 31 (M 1)
pen and ink and graphite on paper
mounted on board
9 1/2 x 13 in. (24.1 x 33 cm)

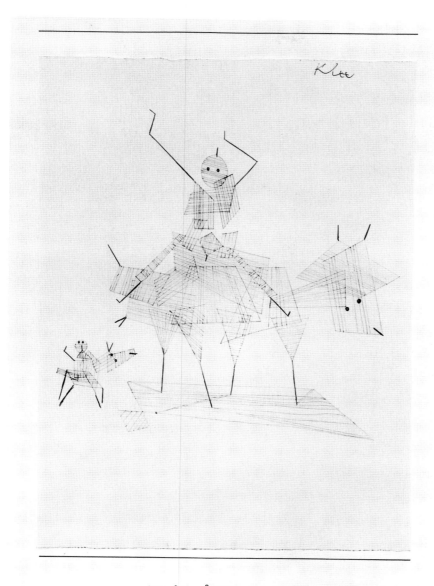

62. *Reiter*
(Rider)
1930, 171 (B 1)
pen and ink on paper mounted
on board
18 1/4 x 13 1/2 in. (46.4 x 34.2 cm)

63. *Erinnerung an Assuan*
(Memory of Aswan)
1930, 185 (C 5)
watercolor and paste on paper
mounted on board
6 3/4 x 20 1/2 in. (17 x 52 cm)

114

64. *Psychogramm mit dem Fuss*
(Psychogram with the Foot)
1930, 66 (P 6)
Inscribed «S Cl»
pen and ink and watercolor on
paper mounted on board
12 1/2 x 19 7/8 in. (31.5 x 48 cm)

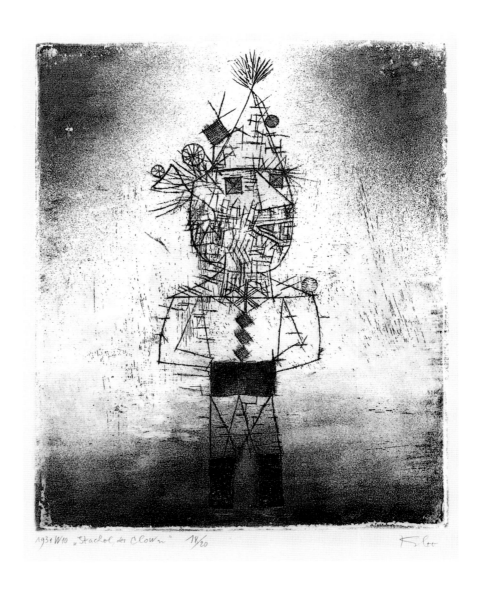

65. *«Stachel der Clown»*
(«Prickle, the Clown»)
1931, 250 (W 10)
etching 18/20
11 7/8 x 9 1/2 in. (30.2 x 24.2 cm)

1931. 16.

66. *Modell 32 b als ungleiche Hälften bei linearer Vermittlung der Geraden* (Model 32 b as unequal halves with linear transmission of the straight lines)
1931, 16 (16)
pen and ink and watercolor on paper mounted on board
17 3/4 x 22 3/4 in. (45 x 58 cm)

67. *Nach «dreier Verworrenheit»*
(der untere Teil umproiciert)
(After «Tangle of Three» [the lower
part reprojected])
1931, 31 (K 11)
pen and ink on paper mounted
on board
15 x 16 1/8 in. (38.1 x 41.3 cm)

68. *Andante*
(Moderately Slow)
1931, 33 (K 13)
watercolor and graphite on paper
mounted on board
22 1/2 x 15 7/8 in. (57.2 x 40.5 cm)

1932 U 9 weñ sie es wüssten

69. *Weñ sie es wüssten*
(If They Only Knew)
1932, 209 (U 9)
ink wash and charcoal on paper
mounted on board
7 5/8 x 8 5/8 in. (19.5 x 22 cm)

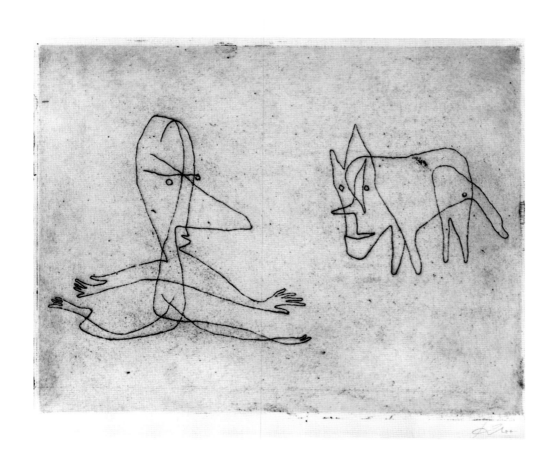

70. *Was läuft er?*
(Why Does He Run?)
1932, 330 (A 10)
etching on zinc
9 3/8 x 11 3/4 in. (23.8 x 30 cm)

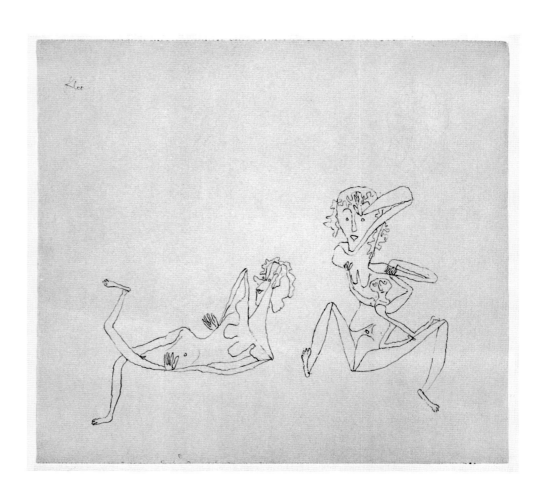

71. *Gefahr!*
(Danger!)
1932, 42 (L 2)
pen and ink on paper mounted
on board
11 5/8 x 15 in. (29.7 x 38 cm)

72. *«Grosser» und kleines Volk*
(«Great One» and Little People)
1932, 105 (P 5)
pen and ink on paper mounted
on board
12 1/4 x 19 in. (31.8 x 48.2 cm)

73. *Untitled*
1932 [006]
plaster relief, painted, mounted
on wood in a tin box
8 5/8 x 9 in. (21.9 x 22.8 cm)

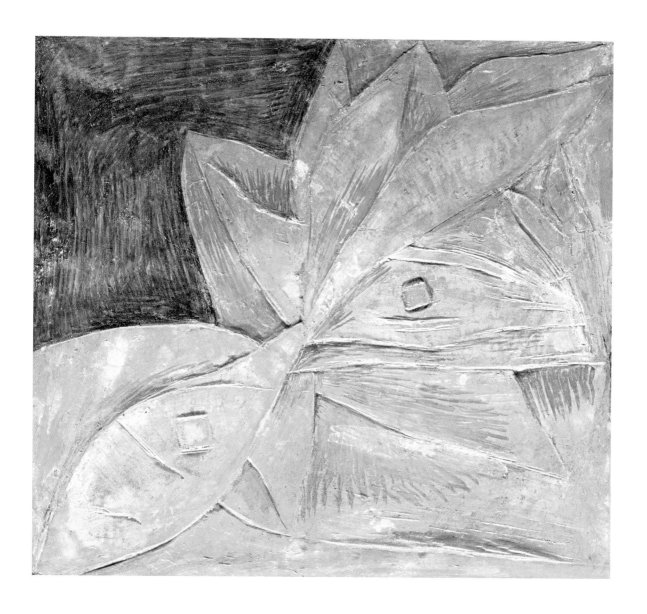

74. *Nachbar-türen*
(Neighboring Doors)
1933, 293 (Z 13)
colored paste and graphite on
paper mounted on board
12 1/2 x 13 in. (31.3 x 33 cm)

49 Charles Miedzinski, *The In-Between World of Paul Klee*, exh. cat. (San Francisco: San Francisco Museum of Modern Art, 1988), 16.
50 Klee made at least two works utilizing this technique. In addition to *Nachbar-türen*, see *Geist des Gewölbes* (Spirit of the Vaults), 1933, reproduced in Christie's, New York, 15 November 1990, lot 156.
51 Grohmann, *Klee*, 273.
52 By contrast, in works from the early 1930s, structure and pattern predominate. For the earlier drawing style, see *Operation (Kurzsichtiger Anatom, zwei Akte)* (Operation [Near-sighted Anatomist, Two Nudes]) and cat. no. 9: *Sechs Akte, «Empfindungen Spazierender»* (Six Nudes, «Strollers' Sensations»), both of 1908. See also, Francis-cono, *Klee*, 104–7.
53 The effect of Germany's unrest permeated certain works by Klee during the 1930s. In particular, it is thought that he may have created a group of drawings with acute political content (whose existence is continually questioned) in 1933. For a discussion, see Franciscono *Klee*, 226–27, 327–30.

During the winter of 1928–29, Klee spent a month in Egypt, whose ancient landscape and architecture inspired a body of work constructed of bands of color. Though made several years after his return, *Nachbar-türen* suggests the tomb sculpture encountered on this trip. The two doors or gates, pictured side by side, form a mysterious, labyrinthine pattern culminating at the center of each door—the two-eyed masklike opening on the left and single-eyed opening on the right. The design recalls the false doors, or entryways for the deceased to reach offerings, located within the chapels of rock-cut tombs, which Klee probably observed in the Valley of the Kings. Painted in ocher, a color suggesting clay or earth, the blocks of the portals simultaneously «conceal and reveal their inner contents.»[49]

With Hitler assuming the position of chancellor, the year 1933 proved highly disruptive for the artist, who left Germany for Switzerland by the year's end. Two noticeable effects of his personal hardship during that time are the decline in creative output and the simplification of technique. Here, a heavy application of colored paste is gingerly scraped off with a small palette knife.[50] With the pigment pushed to the edges of the bars and the paper exposed again, the result is a «ribbon-like surface with a shimmering contour along the edges of the grooves.»[51]

A deep sense of foreboding pervades the work, further heightened by an obfuscated pencil drawing lying deep beneath the viscous surface. The right side of the work serves as the bottom of the underlying structure, where a nude, unearthly man in profile crouches, rendered through nervous, irregular lines. Though difficult to discern completely, the drawing most likely predates the color overlay by several decades. Klee's articulation of the form with loose, short, curved lines is consistent with an expressive drawing style he employed as early as 1908.[52]

With grotesquely exaggerated hands and feet and his head thrown back to reveal a fanged mouth, cackling in laughter or shrieking in pain, the figure trembles in an uncontrolled private moment indicating lunacy or dementia. An amorphous brainlike shape or spirit emanates from the figure's head, evidence, perhaps, of a troubled psyche. In reference to a burial vault, the man might represent the departed with his specter hovering above. On a more intimate level, Klee himself could serve as the subject weighed down by personal demons, behind barricades which metaphorically stand for the neighboring countries of Germany and Switzerland.[53] JB/KP

1933 Z 13 Nachbar. türen

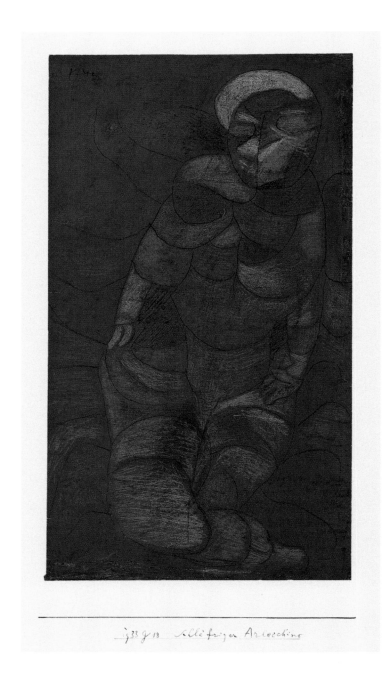

75. *Schläfriger Arlecchino*
(Sleepy Harlequin)
1933, 438 (G 18)
chalk on ground on paper mounted
on board
11 x 6 1/4 in. (28.2 x 15.8 cm)

1933 X 14 Park bild

76. *Park bild*
(Park Construction)
1933, 254 (X 14)
watercolor on ground on paper
mounted on board
12 3/4 x 8 1/8 in. (32.7 x 20.6 cm)

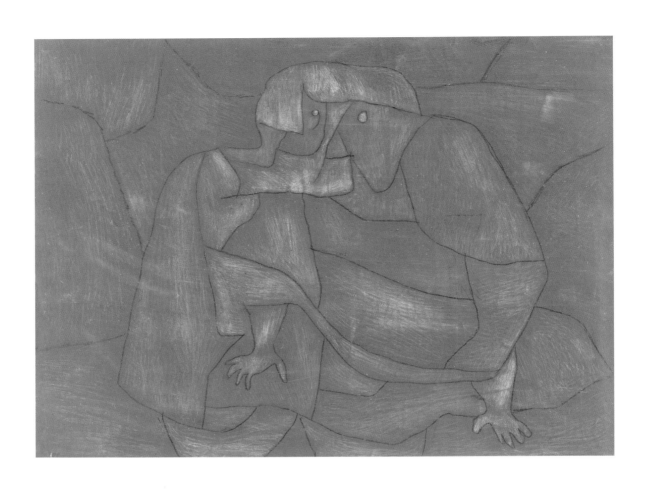

77. *Sibylle*
(Sibyl)
1934, 14 (14)
colored pencil on ground on paper
mounted on board
14 5/8 x 19 1/2 in. (37.4 x 49.4 cm)

78. *Löwenmensch*
(Lion Man)
1934, 2 (2)
watercolor on paper
18 3/4 x 12 in. (47.6 x 30.6 cm)

79. *Der neue Mond*
(The New Moon)
1935, 111 (P 11)
watercolor and charcoal on
ground with incised sketch on
paper mounted on board
11 x 13 3/4 in. (28.1 x 34.8 cm)

I cannot be understood at all on this earth. For I live as much with the dead as with the unborn. Somewhat closer to the heart of creation than usual. But not nearly close enough.[54]

Klee's enduring interest in the interrelationship between the Earth and the cosmos is made conspicuous in *Der neue Mond*. In terms more symbolic than descriptive, the evening landscape addresses the naturally occurring cycles of nature under the new moon. As the dark side of the orb faces the Earth, only a slim blue crescent appears in the sky, offering a single stroke of color in the earthy gray landscape. Lower on the sheet, on the same latitude as a sprouting horizon line, is an ambiguous double circle that appears both womblike and fruitlike, swelling and fertilized. Klee consistently employed a continuous line to articulate forms he identified as fruit in other works of the period.[55] As Richard Verdi has observed, «Nothing proclaims the fecundity and regenerative capacities of nature more than the fruit; and yet its very appearance signals the end of the plant's life-cycle and the beginning of that of another.»[56] If the process of fructification involves the inevitability of ripening and physical death, the composition's soaring diagonals and delicate ladders are metaphors for an ensuing spiritual ascent.

Despite the relative compositional spareness of *Der neue Mond*, the work is a result of multiple processes. Klee prepared the support for this drawing by covering the sheet with a white, gessolike material before applying watercolor with a high pigment-to-water ratio for the gritty, textured background. He then used both watercolor and charcoal to articulate the main lines of the drawing and a needle to incise the ladders directly into the paper. The dark, inky patch in the lower left corner creates the illusion of a dog-eared corner that has been folded over, suggesting that the realm visible from the front might have emerged from or extend to the back. JB

54 Paul Klee, in Franciscono, *Klee*, 188.
55 See, for example, *Die Frucht* (The Fruit), 1932 and *Um den Kern* (Around the Seed), 1935, figs. 104 and 105 respectively, in Richard Verdi, *Klee and Nature* (New York: Rizzoli, 1984), 115–16.
56 *Ibid.*, 118

1935 p. ii der neue Mond

80. *Küste bei Gl.*
(Coast by Gl.)
1937, 37 (K 17)
gouache on ground on paper
mounted on board
10 1/4 x 8 1/4 in. (26.3 x 20.9 cm)

81. *Und schämt sich nicht*
(And Not Ashamed)
1939, 916 (XX 16)
gouache and watercolor on ground
on paper mounted on board
8 7/8 x 11 3/4 in. (22.7 x 29.5 cm)

82. *Untitled*
ca. 1940 [009]
watercolor and paste on paper
7 7/8 x 11 1/2 in. (20.1 x 29.1 cm)

82a. *Untitled*
(verso of cat. no. 82)
ca. 1940
crayon on paper

57 For a close antecedent, see
Rotgrüne und violettgelbe Rhyth-
men (Red-green and Violet-Yellow
Rhythms), 1920, in Sabine Rewald,
Paul Klee: The Berggruen Klee
Collection in The Metropolitan
Museum of Art, exh. cat. (New
York: The Metropolitan Museum
of Art, 1988), 110.
58 Andrew Kagan, in *Guggen-*
heim, 46.
59 *Diaries*, 237, entry 857.
60 Franciscono, *Klee*, 288.
61 Kagan, in *Guggenheim*, 46.
62 In Franciscono, *Klee*, 304.

On 29 June 1940 Klee finally succumbed to the degenerative skin disease scleroderma, leaving several unsigned works of art in his studio. One composition in the atelier discovery made by the artist's son, Felix, is an exceptional untitled work featuring recto and verso images—on the primary (recto) side, a landscape fashioned from rows of vividly colored rectangles, and on the secondary (verso) side, a wide-eyed angel seemingly filled with trepidation.

Recalling the «magic square» paintings Klee started in the 1920s,[57] the principal scene is a latticework of black lines spreading across virtually the entire surface and prohibiting any recession in depth. Though the color washes were laid down first, the bold, flat lines «dictate the order, structure, and modulation of colors.»[58] Two stark houses and several stylized trees, utterly devoid of details, surmount the resultant checkerboard design yet appear subordinate to the rectilinear structure below. The pattern of largely unmodulated colors, separated and isolated from one another, evokes the late studies of Mont Sainte-Victoire by Paul Cézanne, an artist Klee referred to as his «master *par excellence*.»[59]

Indicative of the artist's late style beginning in 1937, lines, which earlier had been thin and attenuated, are transformed into thick painterly sweeps of the brush, retaining their earlier expressive quality while achieving new directness and force. Color equally evolves in Klee's latter years, appearing in limited numbers (usually five to seven), in intensely saturated values, and repeated throughout each work. As Marcel Franciscono has observed, this mature style, however childlike in appearance, enabled Klee to «unite his three components of description, abstract order, and expressive line.»[60]

This line, now rendered in pencil, carries over to the back of the paper. Spare and austere, the angel with folded wings crouches down as if cowering from something alarming—a prospect furthered by its weighty stare. To Klee, angels were «intermediaries between human and divine realms.»[61] Though a salient theme throughout the last two decades of his life, angels became especially prevalent as subject matter from 1937 to 1940. No longer playful, these angels impart a doleful mood, serving as metaphors for Klee's reflections on death. As the artist wrote in a letter to Will Grohmann, «Of course I haven't got into this tragic groove by accident ... the time has come.»[62] KP

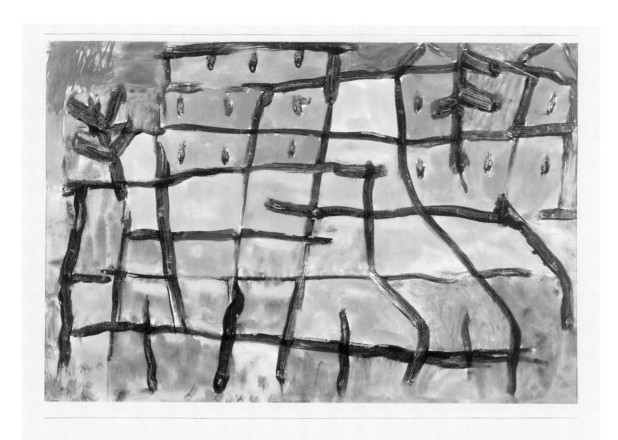

83. *Blau mantel*
(Bluecoat)
1940, 7 (Z7)
oil and pigmented wax on paper
mounted on board
8 7/8 x 10 3/4 in. (22.5 x 27.5 cm)

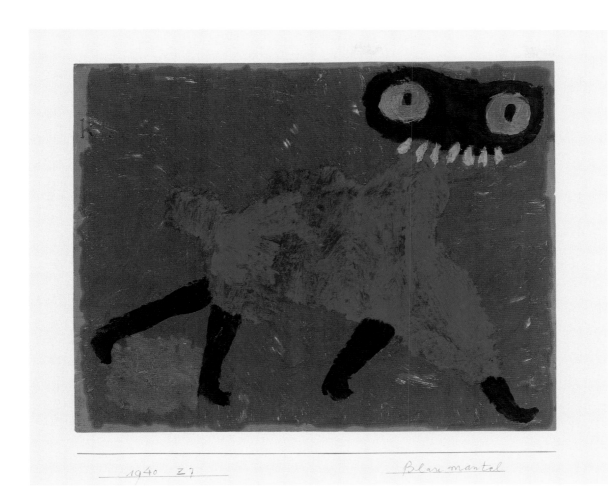

1940 Z7 Blau mantel

Frequently Cited Sources

Diaries

The Diaries of Paul Klee, 1898–1918. Edited by Felix Klee. Berkeley and Los Angeles: University of California Press, 1964.

Franciscono, *Klee*

Franciscono, Marcel. *Paul Klee: His Work and Thought*. Chicago and London: University of Chicago Press, 1991.

Glaesemer, *Klee*

Glaesemer, Jürgen. *Paul Klee: The Colored Works in the Kunstmuseum Bern*. Translated by Renate Franciscono. Bern: Kornfeld and Cie, 1979.

Graphic Legacy

The Graphic Legacy of Paul Klee. Exh. cat. Annandale-on-Hudson, N.Y.: Edith C. Blum Art Institute, Bard College, 1983.

Grohmann, *Klee*

Grohmann, Will. *Paul Klee*. New York: Harry N. Abrams, 1954.

Guggenheim

Paul Klee at the Guggenheim Museum. Exh. cat. New York: Solomon R. Guggenheim Museum, 1993.

Haxthausen, *Klee*

Haxthausen, Charles Werner. *Paul Klee: The Formative Years*. New York: Garland, 1981.

Klee, *Briefe*

Klee, Paul. *Briefe an die Familie, 1893–1940*. Edited by Felix Klee. 2 vols. Cologne: DuMont, 1979.

Klee, «Creative Credo»

Klee, Paul. «Creative Credo.» In *Theories of Modern Art: A Sourcebook by Artists and Critics*. Edited by Herschel B. Chipp. Berkeley: University of California Press, 1968.

Lanchner, *Klee*

Lanchner, Carolyn (ed.). *Paul Klee*. Exh. cat. New York: The Museum of Modern Art, 1987.

Paul Klee – Chronology

1879

18 December: Paul Klee is born in Münchenbuchsee, near Bern. His German father, Hans Klee (1849–1940), taught music at the State teacher's training college, Bern; his mother, Ida Marie Klee, née Frick (1855–1921), trained as a singer at the Stuttgart Conservatory. Klee's sister, Mathilde, was born in 1876.

1880

The Klee family moves to Bern.

1886–1898

Attends elementary school, and (beginning 1890) secondary school in Bern. Starting 1886: violin lessons with Karl Jahn, whom Klee considered an «ideal teacher.»

1898

After finishing secondary school in Bern, Klee (on the recommendation of the Academy Director, Ludwig Löfftz) takes tuition at Heinrich Knirr's private art school, Munich.

1899

Meets the pianist Lily Stumpf (1876–1946), daughter of a Munich doctor.

1900

Enrolls at the Munich Academy of Art, and is allocated to the class of Franz (von) Stuck (1863–1928). Instruction in techniques of etching and modeling.

1901/02

Engagement to Lily Stumpf. Klee travels to Italy with the Swiss sculptor and painter Hermann Haller (1880–1950), followed by return to Bern.

1903

First experiments in etching.

1905

Visits Paris with the Swiss painters Hans Bloesch and Louis Moilliet (1880–1962).
First experiments in painting on glass.

1906

April: Klee visits Berlin with Hans Bloesch.
15 September: marriage to Lily Stumpf. The couple move to Munich and live in Schwabing (Anmillerstrasse).

1907

Attends exhibitions of works by Impressionists and Toulouse-Lautrec (1864–1901).
30 November: birth of Klee's son, Felix (d. 1990).

1908

Intensive study of Van Gogh (1853–1890). Klee attends two exhibitions of his work in Munich.

1909

Admires Cézanne's paintings (1839–1906) in the Munich Secession.

1911

Cycle of drawings on Voltaire's *Candide*.
Meets Blauer Reiter artists, including August Macke (1887–1914), Vassily Kandinsky (1866–1944), and Franz Marc (1880–1916).

1912

February: takes part in the second Blauer Reiter exhibition at Galerie Goltz, Munich.
April: visits Paris a second time, meeting Robert Delaunay (1885–1941), whose essay «Sur la lumière» («On Light») he translates (published in Herwarth Walden's journal *Der Sturm*, no. 144/145, Jan. 1913).

1914

Trip to Tunisia lasting a fortnight with Louis Moilliet and August Macke. The intense North African light inspires him to watercolors. («Color possesses me. … Color and I are one.»)
Founding member of the New Munich Secession.

1915

The poet Rainer Maria Rilke (1875–1926) pays a visit to Klee.

1916–1918

Military service in Landshut, Munich, and Gersthofen (near Augsburg).

1920–1921

«Schöpferische Konfession» («Creative Credo») appears in *Tribüne der Kunst und Zeit*, vol. 13, ed. Kasimir Edschmid (Berlin: Erich Reiss, 1920). («Art does not reproduce the visible, rather it makes visible.»)
Walter Gropius (1883–1969) calls Klee to the Bauhaus as Master. January 1921: Klee begins teaching at the Bauhaus.
September: moves to Weimar. Klee's mother dies in Bern.

Left to right: Vassily and Nina Kandinsky, Georg Muche, Paul Klee, and Walter Gropius. Bauhaus, Dessau, 1926.

1922
Kandinsky begins teaching at the Bauhaus.

1923
«Wege des Naturstudiums» («Ways of Studying Nature») appears in *Staatliches Bauhaus Weimar, 1919–1923* (Weimar, Munich: Bauhausverlag, 1923).

1924
January/February: first exhibition in the United States at the New York Société Anonyme. Emmy Galka Scheyer founds the group «Die Blauen Vier», with Kandinsky, Klee, Lyonel Feininger (1881–1956), and Alexei Jawlensky (1864–1941). Visits Sicily in the summer. Delivers the lecture «Über die moderne Kunst» («On Modern Art») at the Kunstverein Jena (Bern: Benteli, 1945). That winter the Bauhaus is closed, re-opening the following year in Dessau.

1925
«Pädagogisches Skizzenbuch» («Pedagogical sketchbook») appears in the series *Bauhaus-bücher* (Berlin: Albert Langen). Klee's first Paris exhibition.

1926
Moves to Dessau and visits Italy.

1927/28
Visits Porquerolles, near Toulon, and Corsica (1927), and Brittany (1928). «exakte versuche im bereich der kunst» (precise trials in the sphere of art) appears in *Bauhaus. Zeitschrift für Gestaltung*, vol. 2, no. 2/3 (Dessau: 1928).

1928/29
Visits Egypt. Exhibitions at the Galerie Georges Bernheim, Paris, and Galerie Flechtheim, Berlin (both 1929).

1930
Exhibitions in New York, Dresden, Saarbrücken, and Düsseldorf, where Klee takes up a teaching post at the Academy of Art.

1931/32
Terminates Bauhaus contract in favour of the Düsseldorf post (1931). Visits Sicily a second time. Further trips to Venice and Padua. Temporary closure of the Bauhaus (1932).

1933
After the Bauhaus moves to Berlin, the National Socialists enforce its permanent closure. Klee's house in Dessau is searched. Dismissal from the Düsseldorf Academy. December: Klee returns to Bern.

1935/36
After a big retrospective in Bern, first symptoms of the disease scleroderma. Stays for convalescence in Tarasp and Montana.

1937
The «Entartete Kunst» («degenerate art») exhibition at the Haus der Kunst, Munich, displays over a hundred works from public collections, of which seventeen are by Klee. November: Picasso (1881–1973) visits Klee in Bern.

1938
Vacation in Beatenberg.

1939
April: Georges Braque (1882–1963) visits Klee. Autumn: stays at Murtensee. Attends the big Prado exhibition in Geneva. Attempts to gain Swiss nationality are unsuccessful.

1940
10 January: Klee's father dies. February: exhibition in Zurich. Klee's convalescent stay in Tessin ends with admittance to hospital in Locarno-Muralto, where he dies (29 June).

1947
After Klee's wife, Lily, dies in 1946, the Paul Klee Gesellschaft affiliated to the Kunstmuseum Bern is founded, dedicated to the presentation of the museum collection (forty paintings, over two thousand graphic works, sketchbooks, sculptures, paintings on glass, and prints). The foundation also houses the world's most important Paul Klee research center, comprising a comprehensive library, phototheque, as well as collections of letters and critical articles. (Internet access: www.kunstmuseumbern.ch and paulkleezentrum.ch.)

Annotated List of Plates

1. *Untitled*
1895
pen and ink on gold-edged paper
3 x 4 3/4 in. (7.6 x 12 cm)
Extended loan and promised gift
of the Carl Djerassi Trust I

2. *Jungfrau (träumend)*
(Virgin [dreaming])
1903, 2
etching on zinc
9 1/4 x 11 3/4 in. (23.6 x 29.8 cm)
Extended loan and promised gift
of the Djerassi Art Trust

3. *Weib u. Tier (Invention 1)*
(Woman and Beast [Invention 1])
1904, 13
etching on zinc
7 7/8 x 9 in. (20 x 22.8 cm)
Printed by Max Girardet, Bern
Extended loan and promised gift
of the Djerassi Art Trust

4. *Greiser Phönix (Invention 9)*
(Aged Phoenix [Invention 9])
1905, 36
etching on zinc
10 5/8 x 7 3/4 in. (27.1 x 19.8 cm)
Printed by Max Girardet, Bern
Extended loan and promised gift
of the Djerassi Art Trust

5. *Drohendes Haupt (Invention 10)*
(Threatening Head [Invention 10])
1905, 37
etching on zinc
7 x 4 7/8 in. (17.8 x 12.5 cm)
Printed by Max Girardet, Bern
Extended loan and promised gift
of the Carl Djerassi Trust I

6. *Der Held mit dem Flügel*
(The Hero with the Wing)
1905, 38
etching on zinc
10 1/8 x 6 1/4 in. (25.7 x 16 cm)
Printed by Max Girardet, Bern
Extended loan and promised gift
of the Carl Djerassi Trust I

7. *Weibl. Figur, bäurisches Kostüm, von hinten, eine Hand erhoben*
(Female Figure, Peasant Costume, from Behind, One Hand Raised)
1906, 10
pen and ink and wash on paper
mounted on board
8 3/8 x 8 5/8 in. (21.3 x 21.9 cm)
Extended loan and promised gift
of the Carl Djerassi Trust I

8. *Boshaftes Tier, rhinozerosartig mit Jungem*
(Malevolent Animal, Rhinoceros-
like with Calf)
1906, 29
graphite and pigment on paper
mounted on board
3 1/2 x 4 3/4 in. (9 x 12.2 cm)
Extended loan and promised gift
of the Carl Djerassi Trust I

9. *Sechs Akte, «Empfindungen Spazierender»*
(Six Nudes, «Strollers' Sensations»)
1908, 3
pen and ink and graphite on paper
mounted on board
6 7/8 x 8 5/8 in. (17.5 x 22.1 cm)
Extended loan and promised gift of
the Carl Djerassi Trust I

10. *Toten Klage*
(Lamentation of the Death)
1908, 1
pen and ink on paper mounted on
board
7 1/2 x 8 1/4 in. (19 x 21 cm)

Extended loan of the Carl Djerassi
Trust II

11. *Studie nach e. mänlichen Modell (Durchgeistigung durch Primitivität)*
(Study of a male model
[Spiritualization through
Primitiveness])
1909, 67
charcoal, pen and ink and chalk,
and graphite on paper mounted
on board
12 1/8 x 9 in. (30.8 x 22.9 cm)
Extended loan of the Carl Djerassi
Trust II

12. *Die aufregenden Tiere*
(The Agitating Animals)
1912, 127
pen and ink on paper mounted
on board
2 1/2 x 9 1/2 in. (6.5 x 24.1 cm)
Extended loan of the Carl Djerassi
Trust II

13. *Zerstörung und Hoffnung*
(Destruction and Hope)
1916, 55
lithograph with watercolor and
graphite
15 7/8 x 13 in. (40.5 x 33 cm)
Extended loan and promised gift
of the Carl Djerassi Trust I

14. *Initiale*
(Initial)
1917, 11
Inscribed «S Kl»
watercolor, pen and ink, and
graphite on paper mounted
on board
8 3/4 x 4 1/2 in. (22 x 11. 5 cm)

14.a *Untitled*
(verso of cat. no. 14)
ca. 1917

pen and ink on paper
Extended loan and promised gift
of the Carl Djerassi Trust I

15. *Kanal Landschaft*
(Canal Landscape)
1917, 121
pen and ink on paper mounted
on board
3 3/4 x 9 5/8 in. (9.4 x 24.4 cm)
Extended loan of the Carl Djerassi
Trust II

16. *Teppich*
(Carpet)
1917, 70
pastel, wet-in-wet, and watercolor
on Japan paper mounted on board
10 5/8 x 4 in. (27 x 10 cm)
Extended loan of the Carl Djerassi
Trust II

17. *Vogelkomödie*
(Bird Comedy)
ca. 1918
lithograph
16 3/4 x 8 1/2 in. (42.5 x 21.5 cm)
Printed by Kunstanstalt
Franz Hanfstaengl, Munich
Gift of the Djerassi Art Trust
91.330

18. *Fata Morgana zur See*
(Fata Morgana on the Sea)
1918, 12
watercolor and pen and ink on
paper mounted on board
5 x 5 7/8 in. (12.7 x 14.9 cm)
Extended loan and promised gift
of the Carl Djerassi Trust I

19. *Versunkenheit*
(Absorption)
1919, 75
graphite on paper mounted on
board
10 5/8 x 7 5/8 in. (27 x 19.5 cm)

Extended loan and promised gift of
the Carl Djerassi Trust I

20. *Insecten (Schöpfungsplan 24)*
(Insects [Plan of Creation 24])
1919, 114
lithograph with watercolor stencil
8 x 5 5/8 in. (20.6 x 14.5 cm)
Printed by Dr. C. Wolf & Sohn,
Munich
Gift of the Djerassi Art Trust
91.331

21. *Bildnis eines Knaben*
(Portrait of a Boy)
1919, 91
oil transfer drawing on paper
mounted on board
9 3/8 x 7 3/8 in. (24.1 x 19.1 cm)
Extended loan and promised gift
of the Djerassi Art Trust

22. *Ein Genius serviert ein
kleines Frühstück, Engel bringt
das Gewünschte*
(A Spirit Serves a Small Breakfast,
Angel Brings the Desired)
1920, 91
lithograph with watercolor
8 x 5 3/4 in. (20.3 x 14.5 cm)
Extended loan and promised gift
of the Djerassi Art Trust

22.a *Ein Genius serviert ein
kleines Frühstück, Engel bringt
das Gewünschte*
(A Spirit Serves a Small Breakfast,
Angel Brings the Desired)
lithograph
8 x 5 3/4 in. (20.3 x 14.5 cm)
Extended loan and promised gift
of the Carl Djerassi Trust I

23. *Barockbildnis (Herr zu Perrücke)*
(Baroque Portrait [Lord Wig])
1920, 9
watercolor on paper mounted on
board

10 x 7 1/8 in. (25.5 x 18 cm)
Extended loan and promised gift
of the Carl Djerassi Trust I

24. *Die Heilige vom innern Licht*
(The Saint of Inner Light)
1921, 158
graphite on paper
12 1/2 x 8 7/8 in. (31.7 x 22.5 cm)
Gift of the Djerassi Art Trust
91.333

25. *Hoffmanneske Märchen-
scene*
(Hoffmannesque Fairy Tale Scene)
1921, 123
color lithograph
12 1/2 x 9 in. (31.6 x 22.9 cm)
Printed by Staatliches Bauhaus,
Weimar
Gift of the Djerassi Art Trust
91.334

26. *Herz-Dame*
(Queen of Hearts)
1921, 30
lithograph
10 x 6 7/8 in. (25.5 x 17.6 cm)
Extended loan and promised gift
of the Carl Djerassi Trust I

27. *Die Knospe des Lächelns*
(The Budding Smile)
1921, 159
graphite on paper mounted
on board
11 x 6 1/2 in. (28 x 16.5 cm)
Extended loan of the Carl Djerassi
Trust II

28. *Laternenfest Bauhaus 1922*
(Bauhaus Lantern Festival 1922)
1922
lithograph with watercolor
3 1/2 x 5 5/8 in. (8.9 x 14.4 cm)
Printed by Staatliches Bauhaus,
Weimar

Extended loan and promised gift
of the Djerassi Art Trust

29. *Die Hexe mit dem Kamm*
(The Witch with the Comb)
1922, 101
lithograph
12 1/4 x 8 3/8 in. (31 x 21.2 cm)
Gift of the Djerassi Art Trust
91.335

30. *«Lugano»*
(«Lugano»)
1922, 67
lithograph
11 x 15 1/4 in. (27.8 x 38.8 cm)
Extended loan of the Carl Djerassi
Trust I

31. *Vulgaere Komoedie*
(Vulgar Comedy)
1922, 100
lithograph
8 1/2 x 10 3/4 in. (21.5 x 27.3 cm)
Extended loan of the Carl Djerassi
Trust II

32. *Der Verliebte*
(Man in Love)
1923, 91
color lithograph
10 3/4 x 7 1/2 in. (27.4 x 19 cm)
Printed by Staatliches Bauhaus,
Weimar
Gift of the Djerassi Art Trust
91.336

33. *Nordseeinsel*
(North Sea Island)
1923, 180
watercolor on paper mounted to
paper with gouache, mounted
on board
14 1/2 x 20 1/2 in. (37.1 x 51.8 cm)
Extended loan and promised gift
of the Carl Djerassi Trust I

34. *Postkarte zur Bauhaus
Ausstellung «die erhabene Seite»
1923*
(Postcard for the Bauhaus exhibi-
tion «The Sublime Aspect» 1923)
1923, 47
color lithograph
5 5/8 x 3 in. (14.3 x 7.5 cm)
Printed by Staatliches Bauhaus,
Weimar
Extended loan and promised gift
of the Carl Djerassi Trust I

35. *Baltrum (gegen Langeook)*
(Baltrum [toward Langeook])
1923, 264
graphite on paper mounted
on board
5 1/4 x 11 3/4 in. (13.4 x 30 cm)
Extended loan of the Carl Djerassi
Trust II

36. *Postkarte zur Bauhaus
Ausstellung «die heitere Seite»
1923*
(Postcard for the Bauhaus
Exhibition «The Bright Aspect»
1923)
1923, 48
color lithograph
3 7/8 x 5 5/8 in. (9.9 x 14.4 cm)
Extended loan of the Carl Djerassi
Trust II

37. *Mazzaró*
(Mazzaró)
1924, 218
gouache and watercolor on paper
mounted on board
9 1/8 x 12 in. (23.3 x 30.6 cm)
Extended loan and promised gift
of the Carl Djerassi Trust I

38. *Alter Mann*
(Old Man)
1924, 255
oil-transfer and watercolor,

sprayed, on paper, with watercolor
and pen and ink strips top, bottom,
and right, mounted on board
14 1/8 x 9 1/2 in. (36 x 24 cm)
Extended loan of the Carl Djerassi
Trust II

39. *Oriental. Mädchen*
(Oriental Girl)
1924, 256
oil-transfer and watercolor,
sprayed, on paper mounted
on board
11 3/4 x 9 1/8 in. (29.8 x 23.2 cm)
Extended loan and promised gift
of the Carl Djerassi Trust I

40. *Hexe, ihre Tiere entsendend*
(Witch, Dispatching Her Animals)
1924, 35
pen and ink on paper mounted
on board
4 x 9 3/8 in. (10.2 x 23.8 cm)
Extended loan of the Carl Djerassi
Trust II

41. *KRAPP Mein Hund*
(KRAPP My Dog)
1924, 89
pen and ink on paper mounted on
board
11 3/8 x 8 1/2 in. (29 x 21.6 cm)
Extended loan of the Carl Djerassi
Trust II

42. *Kleine Winterlandschaft mit
dem Skiläufer*
(Small Winter Landscape with
Skier)
1924, 85
Inscribed «S Cl»
watercolor on paper mounted
on board
6 x 8 3/4 in. (15.2 x 22.3 cm)
Extended loan of the Carl Djerassi
Trust II

43. *Pferd und Mañ*
(Horse and Man)
1925, 105 (A5)
oil-transfer, pen and ink, and
watercolor, part sprayed, on paper,
mounted on board with watercolor
and pen and ink
13 3/8 x 19 3/4 in. (34 x 50.2 cm)
Extended loan and promised gift
of the Djerassi Art Trust

44. *Figurine mit Kopfputz*
(Figurine with Headdress)
1925, 178 (H 8)
pen and ink and graphite on paper
mounted on board
10 3/4 x 5 in. (27.6 x 12.6 cm)
Extended loan and promised gift
of the Carl Djerassi Trust I

45. *Geburtstags Kind*
(Birthday Child)
1925, 125 (C3)
pen and ink on paper mounted
on board
4 3/8 x 4 in. (11 x 10.1 cm)
Extended loan of the Carl Djerassi
Trust II

46. *Der Dampfer im Hafen*
(Steamship in the Harbor)
1925, 207 (U 7)
oil-transfer and watercolor,
sprayed, on paper mounted
on board
12 5/8 x 18 7/8 in. (32 x 48 cm)
Extended loan of the Carl Djerassi
Trust II

47. *Kopf*
(Head)
1925, 84 (R4)
watercolor, sprayed, on lithograph
8 5/8 x 6 in. (22 x 15.4 cm)
Trial prints printed by
Bauhauspresse Dessau, edition by
O. Felsing, Berlin

Extended loan and promised gift
of the Carl Djerassi Trust I

48. *Bildnisskizze eines jungen Herrn*
(Portrait Sketch of a Young Man)
1925, 32 (M 2)
watercolor on ground on paper
mounted on board
7 1/2 x 5 in. (19 x 12.7 cm)
Extended loan of the Carl Djerassi
Trust II

49. *Wald bei G.*
(Forest near G.)
1925, 139 (D 9)
watercolor, and pen and ink
on paper mounted on board
5 3/8 x 12 3/4 in. (13.7 x 32.4 cm)
Extended loan of the Carl Djerassi
Trust II

50. *Das Sumpfbein*
(The Swamp-Leg)
1926, 9
pen and ink and graphite on paper
mounted on board
7 5/8 x 12 5/8 in. (19.3 x 32 cm)
Extended loan and promised gift
of the Carl Djerassi Trust I

51. *Heldenmutter*
(Hero Mother)
1927, 289 (Ue 9)
watercolor, part sprayed, pen and
ink, and graphite on paper mount-
ed on board with ink and watercol-
or strips added top and bottom
19 1/8 x 12 1/2 in. (48.5 x 31.5 cm)
Extended loan and promised gift
of the Djerassi Art Trust

52. *Pflanzlich – schlimmes*
(Vegetal – Evil)
1927, 119 (B 9)
pen and ink on paper mounted
on board
9 1/4 x 12 1/4 in. (23.5 x 31 cm)

Extended loan and promised gift
of the Carl Djerassi Trust I

53. *Negride Schönheit (Præcision)*
(Negroid Beauty [Precision])
1927, 192 (T 2)
pen and ink and graphite on paper
mounted on board
17 1/4 x 13 in. (44 x 33 cm)
Extended loan of the Carl Djerassi
Trust II

54. *Porquerolles*
(Porquerolles)
1927, 195 (T 5)
pen and ink, chalk, and graphite
on paper mounted on board
12 x 18 in. (30.5 x 45.7 cm)
Extended loan of the Carl Djerassi
Trust II

55. *Weñ sie nicht mehr dran
glauben*
(When They Do Not Believe It
Anymore)
1927, 259
pen and ink on paper mounted
on board
12 x 18 1/4 in. (30.5 x 46.5 cm)
Extended loan of the Carl Djerassi
Trust II

56. *Grosses Tier*
(Large Beast)
1928, 50 (N10)
watercolor, part sprayed, and pen
and ink on paper, mounted to
board with gouache strips added
left and right
14 3/4 x 12 5/8 in. (37.5 x 32.1 cm)
Extended loan and promised gift
of the Djerassi Art Trust

57. *Aus Meinem Auge! Schnecke!*
(Out of my Eye! Snail!)
1928, 182 (J 2)
pen and ink on paper mounted
on board

13 x 8 1/4 in. (33 x 21 cm)
Extended loan of the Carl Djerassi
Trust II

58. *Rotes Haus*
(Red House)
1929, 223 (W 3)
oil on canvas mounted on card-
board
10 x 10 7/8 in. (25.4 x 27.6 cm)
Gift of the Djerassi Art Trust
92.261

59. *Was für ein Pferd!*
(What a Horse!)
1929, 264 (AE 4)
Inscribed «S Cl»
pen and ink and watercolor on
paper mounted on board
9 1/4 x 12 1/4 in. (23.4 x 31 cm)
Gift of the Carl Djerassi Trust I
92.262

60. *Rechnender Greis*
(Old Man, Reckoning)
1929, 99 (S 9)
etching, A.P., 125
11 3/4 x 9 3/8 in. (29.9 x 23.9 cm)
Printed by Hans Klinger, Leipzig
Extended loan and promised gift
of the Carl Djerassi Trust I

61. *Überbeschwingte I*
(The Over-elated Ones I)
1930, 31 (M 1)
pen and ink and graphite on paper
mounted on board
9 1/2 x 13 in. (24.1 x 33 cm)
Extended loan and promised gift
of the Carl Djerassi Trust I

62. *Reiter*
(Rider)
1930, 171 (B 1)
pen and ink on paper mounted
on board
18 1/4 x 13 1/2 in. (46.4 x 34.2 cm)

Extended loan of the Carl Djerassi
Trust II

63. *Erinnerung an Assuan*
(Memory of Aswan)
1930, 185 (C 5)
watercolor and paste on paper
mounted on board
6 3/4 x 20 1/2 in. (17 x 52 cm)
Extended loan of the Carl Djerassi
Trust II

64. *Psychogramm mit dem Fuss*
(Psychogram with the Foot)
1930, 66 (P 6)
Inscribed «S Cl»
pen and ink and watercolor on
paper mounted on board
12 1/2 x 19 7/8 in. (31.5 x 48 cm)
Extended loan of the Carl Djerassi
Trust II

65. *«Stachel der Clown»*
(«Prickle, the Clown»)
1931, 250 (W 10)
etching 18/20
11 7/8 x 9 1/2 in. (30.2 x 24.2 cm)
Gift of the Djerassi Art Trust
91.339

66. *Modell 32 b als ungleiche
Hälften bei linearer Vermittlung
der Geraden*
(Model 32 b as unequal halves
with linear transmission of the
straight lines)
1931, 16 (16)
pen and ink and watercolor on
paper mounted on board
17 3/4 x 22 3/4 in. (45 x 58 cm)
Extended loan and promised gift
of the Carl Djerassi Trust I

67. *Nach «dreier Verworrenheit»
(der untere Teil umproiciert)*
(After «Tangle of Three» [the lower
part reprojected])

1931, 31 (K 11)
pen and ink on paper mounted
on board
15 x 16 1/8 in. (38.1 x 41.3 cm)
Extended loan and promised gift
of the Carl Djerassi Trust I

68. *Andante*
(Moderately Slow)
1931, 33 (K 13)
watercolor and graphite on paper
mounted on board
22 1/2 x 15 7/8 in. (57.2 x 40.5 cm)
Extended loan of the Carl Djerassi
Trust II

69. *Weñ sie es wüssten*
(If They Only Knew)
1932, 209 (U 9)
ink wash and charcoal on paper
mounted on board
7 5/8 x 8 5/8 in. (19.5 x 22 cm)
Extended loan and promised gift
of the Carl Djerassi Trust I

70. *Was läuft er?*
(Why Does He Run?)
1932, 330 (A 10)
etching on zinc
9 3/8 x 11 3/4 in. (23.8 x 30 cm)
Gift of the Djerassi Art Trust
91.340

71. *Gefahr!*
(Danger!)
1932, 42 (L 2)
pen and ink on paper mounted
on board
11 5/8 x 15 in. (29.7 x 38 cm)
Extended loan and promised gift
of the Carl Djerassi Trust I

72. *«Grosser» und kleines Volk*
(«Great One» and Little People)
1932, 105 (P 5)
pen and ink on paper mounted
on board

12 1/4 x 19 in. (31.8 x 48.2 cm)
Extended loan of the Carl Djerassi
Trust II

73. *Untitled*
1932 [006]
plaster relief, painted, mounted on
wood in a tin box
8 5/8 x 9 in. (21.9 x 22.8 cm)
Extended loan of the Carl Djerassi
Trust II

74. *Nachbar-türen*
(Neighboring Doors)
1933, 293 (Z 13)
colored paste and graphite on
paper mounted on board
12 1/2 x 13 in. (31.3 x 33 cm)
Gift of the Djerassi Art Trust
88.511

75. *Schläfriger Arlecchino*
(Sleepy Harlequin)
1933, 438 (G 18)
chalk on ground on paper mount-
ed on board
11 x 6 1/4 in. (28.2 x 15.8 cm)
Extended loan of the Carl Djerassi
Trust II

76. *Park bild*
(Park Construction)
1933, 254 (X 14)
watercolor on ground on paper
mounted on board
12 3/4 x 8 1/8 in. (32.7 x 20.6 cm)
Extended loan of the Carl Djerassi
Trust II

77. *Sibylle*
(Sibyl)
1934, 14 (14)
colored pencil on ground on paper
mounted on board
14 5/8 x 19 1/2 in. (37.4 x 49.4 cm)
Gift of the Djerassi Art Trust
88.512

78. *Löwenmensch*
(Lion Man)
1934, 2 (2)
watercolor on paper
18 3/4 x 12 in. (47.6 x 30.6 cm)
Extended loan and promised gift
of the Djerassi Art Trust

79. *Der neue Mond*
(The New Moon)
1935, 111 (P 11)
watercolor and charcoal on ground
with incised sketch on paper
mounted on board
11 x 13 3/4 in. (28.1 x 34.8 cm)
Extended loan and promised gift
of the Djerassi Art Trust

80. *Küste bei Gl.*
(Coast by Gl.)
1937, 37 (K 17)
gouache on ground on paper
mounted on board
10 1/4 x 8 1/4 in. (26.3 x 20.9 cm)
Extended loan of the Carl Djerassi
Trust II

81. *Und schämt sich nicht*
(And Not Ashamed)
1939, 916 (XX 16)
gouache and watercolor on ground
on paper mounted on board
8 7/8 x 11 3/4 in. (22.7 x 29.5 cm)
Extended loan and promised gift
of the Djerassi Art Trust

82. *Untitled*
ca. 1940 [009]
watercolor and paste on paper
7 7/8 x 11 1/2 in. (20.1 x 29.1 cm)

82a. *Untitled*
(verso of cat. no. 82)
ca.1940
crayon on paper
Gift of the Djerassi Art Trust
88.513

83. *Blau mantel*
(Bluecoat)
1940, 7 (Z7)
oil and pigmented wax on paper
mounted on board
8 7/8 x 10 3/4 in. (22.5 x 27.5 cm)
Extended loan of the Carl Djerassi
Trust II

Photographic Acknowledgments

The Kunsthalle Krems and Prestel-Verlag gratefully acknowledge permission to reproduce and publish the photographic material in this volume.

San Francisco Museum of Modern Art, pp. 12, 13; cat. nos. 32, 41, 43, 45–47, 54, 59, 61, 67, 72, 73, 80; Photo Ben Blackwell, cat. nos. 1–31, 33–37, 39, 40, 42, 44, 48, 50–52, 55, 56, 58, 60, 62, 64–66, 68–71, 75, 77–79, 81–83; Photo Ian Reeves, cat. no. 53; Photo Phil Hofstetter, cat. no. 74

Carl Djerassi, San Francisco, cat. nos. 38, 49, 57, 63, 76

Estate of the Klee family, Paul-Klee-Stiftung Bern, p. 142; Photo F. Fuss, Frontispiece; Photo Foto-press/Photo Walter Henggeler, p. 22

Barbara Schwanhäuser, Freiburg, p. 14